SHAPING LIGHT

**GLENN RAND
AND TIM MEYER**

AMHERST MEDIA, INC. ☐ BUFFALO, NY

DEDICATION

This book is dedicated to those who see the light and want to modify it.

Facing page photo by Tim Meyer.

Published by:
Amherst Media, Inc.
P.O. Box 586
Buffalo, N.Y. 14226
Fax: 716-874-4508
www.AmherstMedia.com

Publisher: Craig Alesse
Senior Editor/Production Manager: Michelle Perkins
Associate Editor: Barbara A. Lynch-Johnt
Associate Publisher: Kate Neaverth
Editorial Assistance from: Carey A. Miller, Sally Jarzab, John S. Loder

Business Manager: Adam Richards
Warehouse and Fulfillment Manager: Roger Singo

ISBN-13: 978-1-60895-705-7
Library of Congress Control Number: 2013952527
10 9 8 7 6 5 4 3 2 1

Check out Amherst Media's blogs at:
http://portrait-photographer.blogspot.com/
http://weddingphotographer-amherstmedia.blogspot.com/

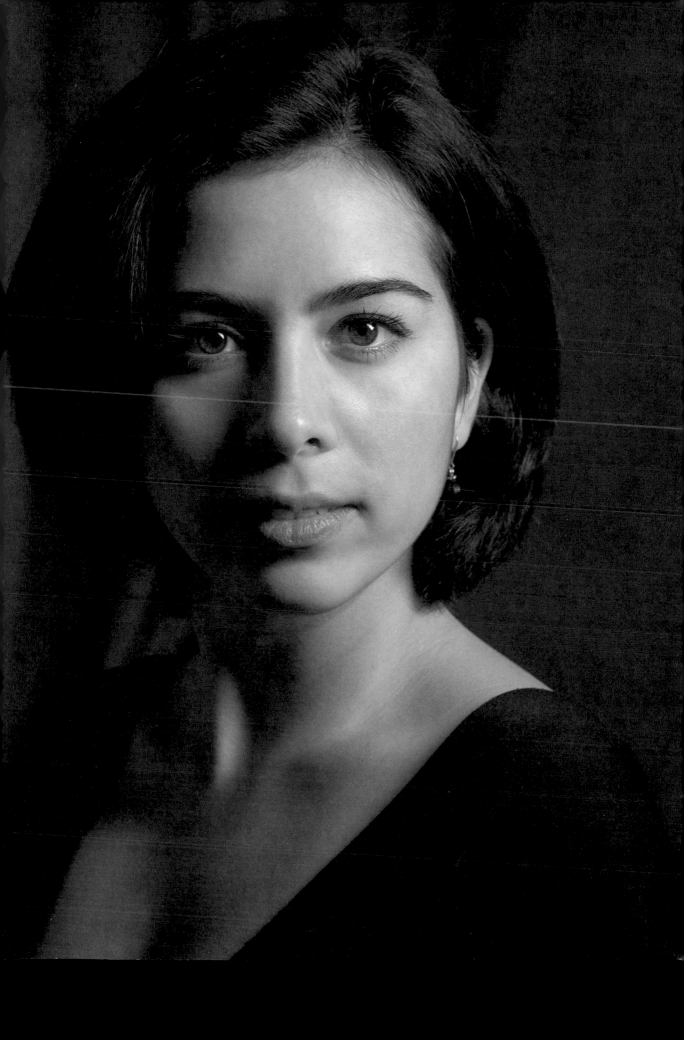

CONTENTS

Photograph by Nick Korompilas.

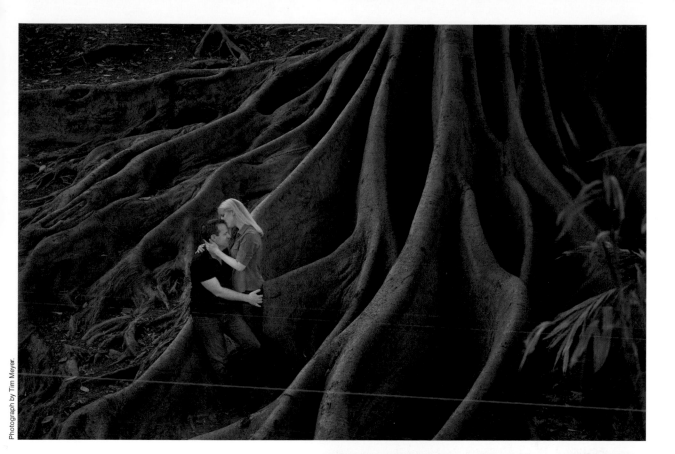

Photograph by Tim Meyer.

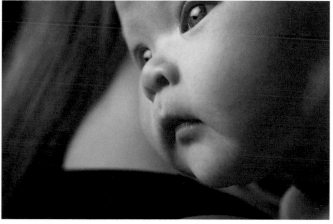

Photograph by Allison Flowers.

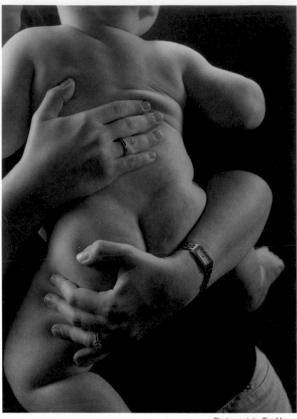

Photograph by Tim Meyer.

Photograph by Tim Meyer.

ACKNOWLEDGMENTS

This book would not be possible without the assistance of many individuals. We received assistance from Bill Gratton, Mark Rezzonico, and Magnus Olofsson of Profoto. As you will see throughout the book, we were assisted by our primary models Chelse, Faith, and Kelly as well. Of course, we owe thanks to the photographers who graciously shared their work with us–Brenden Butler, Randy Duchaine, Allison Flowers, Judy Host, Nick Korompilas, Thomas James, and Al Redding. Finally, this book would not be possible without the support of our spouses, Dea and Sally.

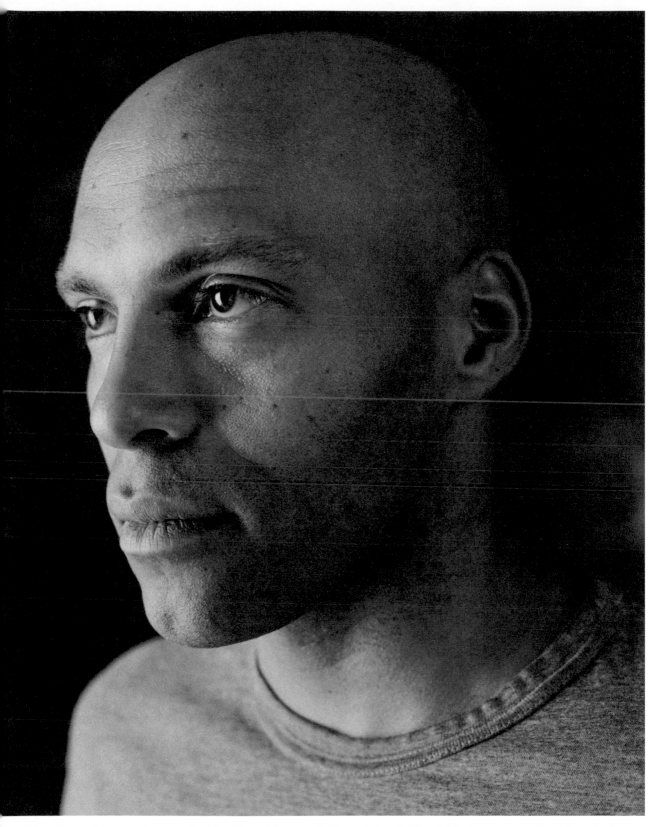

A Profoto D1 monolight was placed on the left of the subject. The light was diffused with a 6x6-foot scrim to create distinct shadows on the man's face. The ambient light in the studio provided fill. *Photograph by Nick Korompilas.*

1

INTRODUCTION

We start this book with this image by Judy Host because it tells photographers a beautiful story about the way light can be used. In this image, Judy previsualized how she wanted to have the model's face become and emerge from the leaves. She created the medallion of leaves separately and then made the photograph of the model to fit the structure of the medallion. The result is reminiscent of Yin-Yang.

This book is about light used in photography. It seems strange that we would start the discussion with the simple, easy-to-assume concept that light is required for photography. However, as we will show in this book, light by itself usually does not produce the style, energy, emotion, or feeling that makes a photograph exceptional. While the light is required to make the photograph, it is the way the light has been modified and shaped by natural or man-made controls that gives the photographer the ability to create an image that will communicate their feeling about the subject of their image.

To give a better understanding of how you will be able to control the light that you choose to use in your photographs, we will go through a series of discussions defining the light itself; the surfaces that will interact with the light in the photographs; the quality of light that we wish to create; and the tools, modifiers, and shapers that are commonly available for our use.

As we progress through the book, you will find that the discussions of light and how it is modified or shaped is described both in words and through images. The images will show the way the light is seen in a photograph, and there will also be images to show the final results that can be achieved with the various types of modifications and shaping of light.

Light modification happens in all situations, even on a clear-sky sunny day. This book deals with how you, the photographer, can use various tools to modify the light to produce your intended images. Therefore, we will not deal with ambient light situations that accept the light as it is found. However, we will discuss how to approximate these life situations should you want them to appear in a studio or controlled light scenario.

Light modification happens in all situations, even on a clear-sky sunny day.

While there are many types of lighting sources that are used for photography, this book will treat the light emanating from these sources without regard to how the light itself was produced. It is the intent of this book to show the effect of modifiers and shapers on the quality of light rather than to discuss the merits of any particular light source.

The images in the book are heavily captioned with information about the light that the modifiers produce and its characteristics. However, you will notice that the captions do not provide the exposure settings for the camera or power (f-stop) settings for

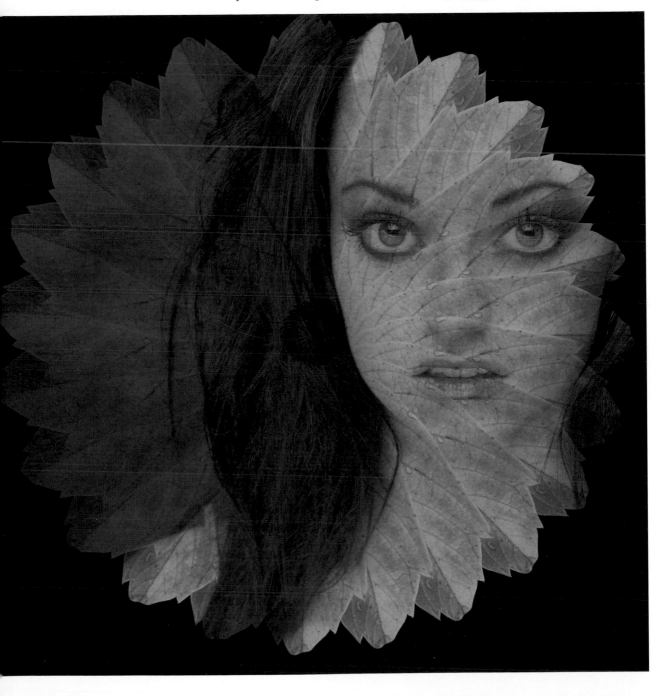

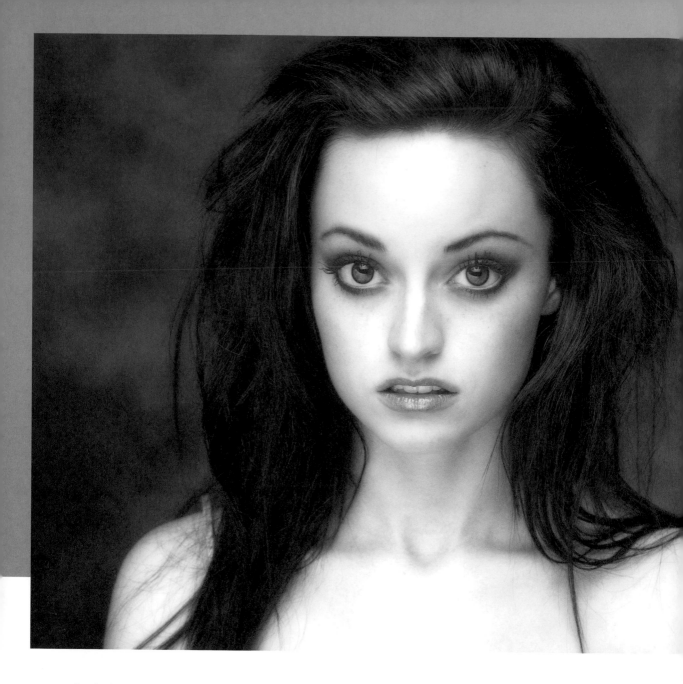

the lighting equipment. This is intentional, as the light will vary dramatically depending on the light unit's settings, the distance the light modifier is from the image area that is illuminated, and how multiple modifiers' light interacts. It is not our intent to produce recipes that can be used to achieve good photographs without fail, but to show the creativity that can be achieved by applying light to various photographic approaches. With an expansive use of light modifiers, exposure values will likely change greatly.

To accomplish the lighting for this portrait, a large horizontal softbox was used above the camera. To create the fill, a silver reflector was placed directly in front of the model, producing a "clamshell" light pattern. *Photograph by Judy Host.*

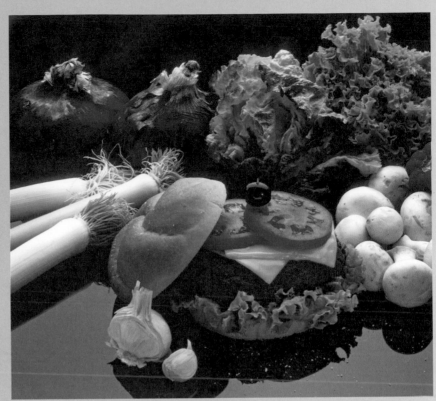

The image above is a combination of the two distinct light and surface characteristics, specular and diffuse. The diffuse light from a large softbox directly above the set provided the overall lighting and produced the large soft reflections on the specular surfaces (olive, tomatoes, and Plexiglas). The light also gave shape to the diffuse surfaces (bun, mushrooms, etc.). The specular light was provided by a mini Fresnel spotlight at a great distance. This created the specular reflection on the olive and edge detail on the cheese. A white card was placed in front of the set to produce fill light for the set. *Photograph by Glenn Rand.*

> **With an expansive use of light modifiers, exposure values will likely change greatly.**

Throughout the book there will be diagrams of lighting setups that were used to demonstrate various light modifiers and shapers. These diagrams are stylized and not to scale. As with the images that the diagrams describe, we believe that our lighting is *a* method, not the *only* way to achieve great images. Therefore, we chose to show the basic positions of various modifiers and not to make specific examples in our diagrams.

Also, no camera information is given in the diagrams or in their captions. This is because correct exposure is dependent on variables of the lights, and what may have been used for our examples might be misleading. Beyond the issue of any particular exposure setting, the position of the camera does not affect exposure.

This book does not differentiate between digital photography and film-based photography. While there are some small differences in the way exposure takes place in these different technologies, they do not change the way the light is controlled to make exposures. *Photograph by Brenden Butler.*

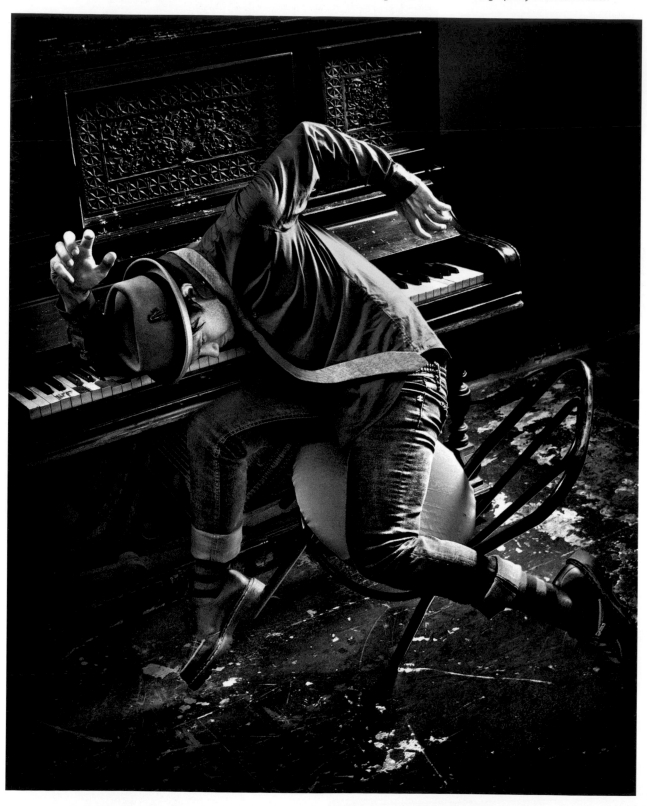

Tim Meyer created classic beauty lighting for this image. He used a modified clamshell light concept to produce smooth, non-directional flat lighting. To create the clamshell, a 7-foot silver umbrella was used on the camera axis. Because the model faced across the light from the giant umbrella, shadows on her face were minimized. To finish the clamshell, two 1x6-foot softboxes were set on the floor in front of the model and aimed at her face. The softboxes created a uniform fill that removed any shadows from her face. A monoblock was used to illuminate the background and bring its tone to the desired level.

SIMPLIFIED LIGHT CONCEPTS

2

LIGHT

We must have a basic understanding of what light is and how it presents itself so that we will have better control to make our photographs. To use a common definition, light is an energy that makes vision and, by extension, photography possible.

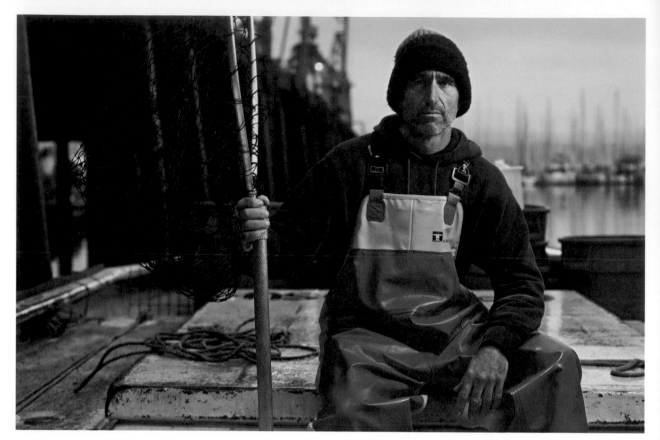

In photography, the light that is used to make exposures comes from a variety of sources. The sun is the most-used source. Other common sources are continuous lights such as tungsten or photofloods, electronic flash, fluorescent bulbs, light-emitting diodes (LEDs), and ambient light sources. All of these sources or situations have several commonalities that give us the ability to modify and shape the light that will be captured in our photographs.

Light is a radiant energy source that is part of the electromagnetic spectrum. For our purposes, we will deal only with that part of the electromagnetic spectrum that can be seen or captured by conventional photographic equipment. This includes visible light, a small portion of ultraviolet light, and a small portion of infrared light. While there are other energy sources within the electromagnetic spectrum, they are not commonly used in photography.

Direction. The key statement above is that light is a *radiant* energy source. This means that when light is created, the energy moves out from the source in all directions. Because light radiates, the first control that must be applied in order to perform any

This image was created by adding a strong beam of light to the very diffuse foggy evening light of the scene. The modified light, a speedlight fired through a circular diffusion panel, was positioned to produce a very tight closed-loop lighting. This created strong contours on the subject without producing noticeable shadows on the area around the subject. *Photograph by Nick Korompilas.*

kind of modification or shaping is making the light directional. Within lighting equipment, this is done primarily with reflectors. While reflectors are a type of modifier, we can think of them as the first ingredient providing us with control—the ability to create direction for the light source.

As we create directionality, the light energy becomes more of a beam structure. This means that we can define a pattern that the light will create when it illuminates the subject. The beam need not be and often is not consistent. Depending on how the light is

As we create directionality, the light energy becomes more of a beam structure.

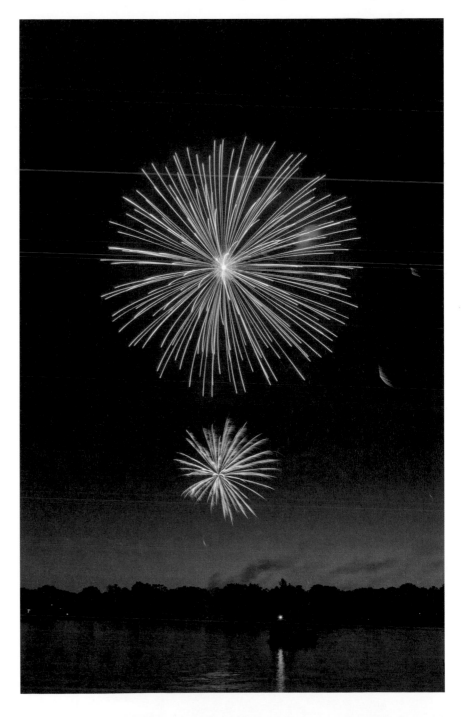

This photograph of fireworks shows radiant energy, and in this case, light energy too. As with the exploding aerial display, the energy starts at a single point and then radiates in all directions. This is why the fireworks look similar from all vantage points. *Photograph by Glenn Rand.*

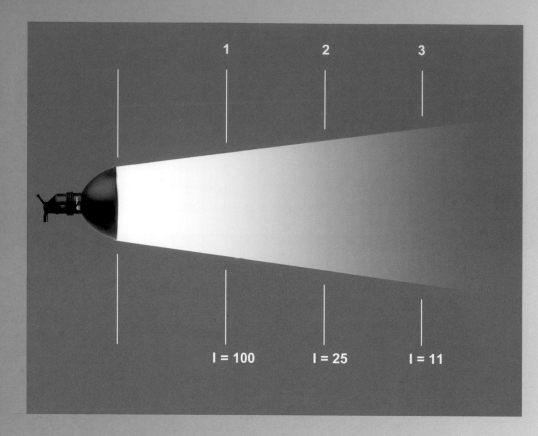

1 2 3

I = 100 I = 25 I = 11

If we measure the light at 1 unit distance from the source and it reads 100 in light value, when reading the value at 2 units distance from the light, the reading will be $1/4$ or 25. If a value reading is taken at 3 units, then the reading would be $1/9$ or about 11.

formed into a beam it will be more or less consistent. Unless the beam is coherent or focused, there will be a certain amount of spread in the beam. While some modifiers make the beam take on parallel characteristics, this is not the most common or ordinary beam structure. Most of the beam structure of the light source prior to being modified will retain some of its radiant quality, meaning that there will be a certain amount of spread in the beam from the light source to the subject.

Intensity and the Law of the Inverse Square. For our purposes, we must consider that as the beam of light moves farther from the source, its intensity will lessen. While photographing the source in itself is not changed by distance, the illumination effect of the light reduces rapidly as the beam travels away. The amount of loss follows a specific formula. This is known as the Law of the Inverse Square. The actual formula for this law is:

$$E = I \cos Q/d^2$$

As the beam of light moves farther from the source, its intensity will lessen.

where E is the final energy, I is the initial intensity and d is the amount of change in distance. The cos Q indicates that the spread of the beam will affect the formula. The most common interpretation of the Law of the Inverse Square is that cos Q is assumed to be equal to 1 or that the change in light intensity is measured on the center of the beam. In this form, we consider the energy, E (light intensity), to be equal to 1 divided by the change of distance squared, giving the more commonly expressed equation:

$$I = 1/\Delta d^2$$

where I is the new intensity and Δd is the new distance from the light source to the subject divided by the previous distance. If the light-to-subject distance is increased, then the new intensity of the light at the subject will decrease, and when the light-to-subject distance is decreased, the intensity of the light at the subject is increased.

As examples, if you double the distance a light is from the subject, you decrease the intensity to $1/4$ its energy. (This is equivalent to a two-stop change in intensity.) A further example, if you triple the distance, from 1 foot to 3 feet, the new intensity will be $1/9$ the original intensity. On the other hand, if the subject-to-light distance is decreased from 6 feet to 3 feet, then the intensity of the light at the subject is increased four times (two stops more intensity).

We have taken this time to discuss the Law of the Inverse Square because it is one of the major tools in controlling the light intensity that will be used for exposure. Regardless of the type of light, with few exceptions, the intensity of the light on the subject will be changed if the subject-to-light distance is changed.

Color. Another common characteristic of light that can be modified is its color. All light, regardless of how it is perceived, has an inherent color bias. While we may not be able to see this color bias when looking at the light itself, it is there. For example, fluorescent lights have a greenish cast, tungsten lights have an orange bias, and electronic flash is bluish. This color bias may or may not be beneficial to our photography but is totally controllable with either in-camera white balance, film type, or filtration.

If you double the distance a light is from the subject, you decrease the intensity to $1/4$ its energy.

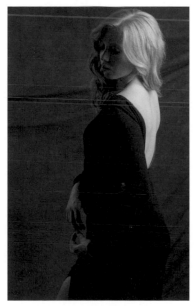

The Law of the Inverse Square is a major tool in controlling the light intensity that will be used for exposure. Regardless of the type of light, with few exceptions, the intensity of the light on the subject will be changed if the subject-to-light distance is changed. *Photograph by Tim Meyer.*

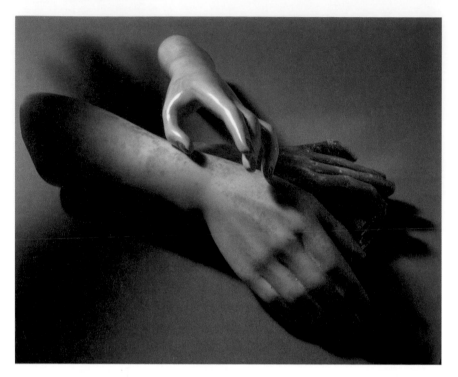

This demonstration image shows the effect of specular light on various surfaces. The specular nature of the light can be seen by the crisp, dark shadows. The mannequin hand on top is a glossy specular surface. The highlights on the above hand are bright and sharp and the shadows have a crisp LDE (light's dynamic edge). The two lower hands have diffuse surfaces. The highlights are spread out and softened and the shadows, while dark, have less defined LDEs and show the changes in surface volume. Photograph by Glenn Rand.

LIGHT'S DYNAMIC EDGE (LDE)

As light strikes a surface, it interacts based on both its characteristic and the type of surface. As the surface is deformed with the light at an angle to the surface, the difference between the lit area and the shadow edge is formed. The dynamics exhibited in this edge are created by the characteristic of the light and the type of surface. For example, if the surface is diffuse (matte or textured), a diffuse light source will create a smooth transition, while a specular source will create a crisper LDE.

The last major characteristic of light that we need to introduce before going forward is its specular/diffuse nature. This will be discussed more fully in the next chapter, but at this point in our discussion we need to mention that this is the hardness or softness of the light as it illuminates the subject.

SURFACES

Very seldom do we see light itself. The light's beam is only seen as it reflects off the particles in the air, such as when light passes through fog or smoke. Therefore, we relate to light as it reflects from subjects that we see or photograph. In the scheme of things, the surface of the subject of our photograph affects the way we see the light that is illuminating that subject.

Subjects are made up of a variety of surfaces. Some are smooth and shiny while others are highly textured. The way light interacts with the surfaces is important in how we photograph and how the images will look after exposure. When the surface of the subject is shiny, it is considered specular; when a bright light is reflected off of a highly reflective, shiny subject, a specular highlight is seen. (To picture this, imagine the effect of shining a bright light off of a highly reflective surface, like a car's chrome bumper.) Highly

textured surfaces such as cotton cloth or the surface of a tennis ball are diffuse surfaces. When a bright light strikes a diffuse surface, the highlights are spread out and softened and the shadows, while dark, have less-defined LDEs and show the changes in surface volume.

It is obvious that surfaces are not always either specular or diffuse. Surfaces range in the way they reflect light, from mirror-like in the case of a car's bumper, to smooth semi-reflective surfaces such as satin, to cotton cloth, and finally to fresh mountain grass. The surfaces will reflect whatever light is shone upon them, and

The diffuse light for this image allows the nature of the surface to be seen. The plate and flatware have specular surfaces while the pie, whipped cream, and black placemat have diffuse surfaces. With the specular surfaces, the polished metal parts fully reflect the diffuse light source–the fork reflects the pie, and the shiny black plastic on the flatware and the black-glazed plate reflect the light source (though it is reduced by the background color of the material). The most diffuse surface is the black placemat; it offers little reflection. The pie crust shows what we expect from a diffuse surface under a diffuse light with good detail without strong texture. The whipped cream shows a variation of lightness depending on its angle to the light. *Photograph by Glenn Rand.*

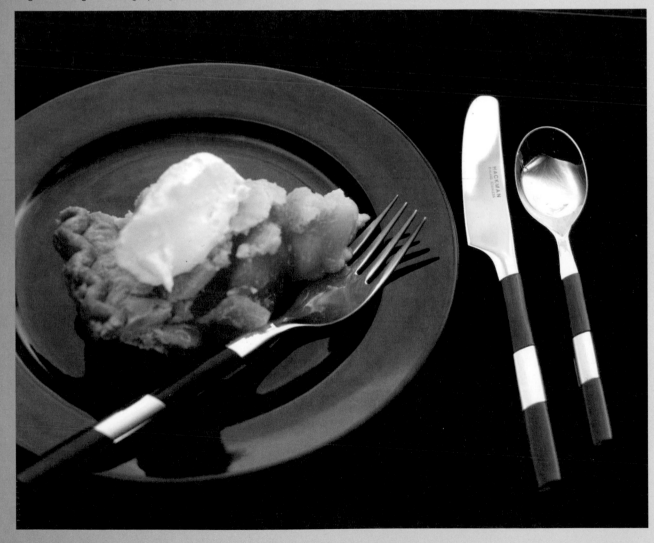

the quality of the reflection that will be able to be photographed will vary greatly depending on the nature of the surface.

A highly specular surface such as a chrome car bumper or colored glass Christmas tree ornament will reflect the light illuminating it as a distorted light spot, the specular of the light source. If the surface is smooth and flat, there will be a small amount of distortion in the reflected image of the light. The effect of the light on a specular surface will be to increase the contrast seen in the object.

ABOUT HIGHLIGHTS

Highlights' dynamics are not as easy to see compared to shadows. However, the highlights provide the fullness and volume in the image. On a very diffuse surface, highlights will spread. As the surface becomes more specular, the highlight becomes more intense and confined. When the surface is shiny, the highlight will be reflected as a crisp form representing the shape of the source.

In this image there are both specular and diffuse surfaces. Because the Brussels sprout was glazed and the model's lips were glossed, these surfaces, like the fork and jewelry, are specular and look shiny, reflecting "hot spots." The model applied a flat pancake base on her skin; this diffused the light and spread it across her skin. *Photograph by Glenn Rand.*

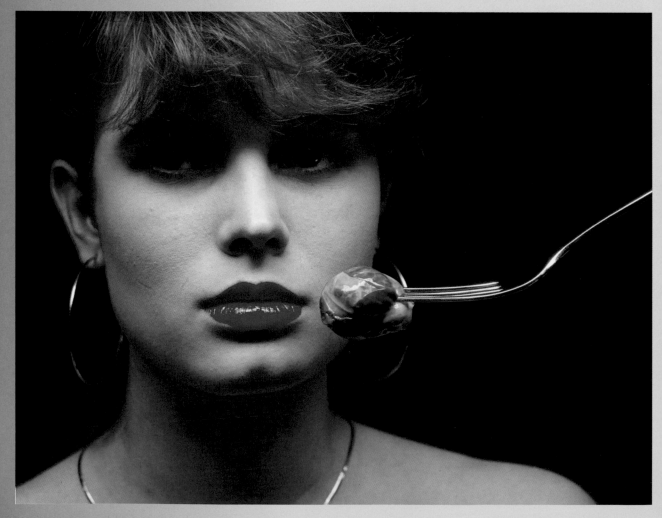

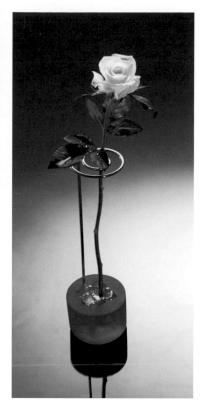

To create this photograph, the effects of three Fresnel spots were used. Since the piece was sitting on black Plexiglas, the first spot was shown on the background in order to create a reflected pool of light behind the subject. The second spot was used to illuminate the flower and stand. This light was aimed and goboed to keep it from shining directly on the base or chrome stand. The third and smallest spot was aimed at a mirror in front of and below the flower to reflect fill into the underside of the blossom. The light from the mirror was gelled blue to create a complementary color fill on the flower and thus increase the visual separation of the petals. Photograph by Glenn Rand.

A moderately specular surface such as satin or moist skin will give a strong reflection from the light source while allowing it to spread out across the surface. Once again, if the surface is distorted, the spread of the hot spot will follow the contours of the distortion, while the other portions of the surface will accept and reflect portions of the light.

As the surface becomes more and more diffuse, the reflection of the light from the surface is less and less distinct. A very diffuse surface will appear to be lit evenly when in the light's beam. While there is reflection from the surface, the light reflecting is scattered by the surface's texture.

If we think of a portrait of a young woman with makeup on her face, we can see all three of the just mentioned surfaces in the image. The eyes are specular surfaces, and the light illuminating the portrait is often caught in the eye and creates what is known as a catchlight (a direct reflection from the light source distorted by the curvature of the eye's surface). If she had matte powder on her face, her skin would have a diffuse surface. The light illuminating the skin would present as even, the tones would be smooth, and there would be no strong highlights. Finally, her washed, conditioned, smoothly combed hair would fall somewhere between the specular nature of the catchlight and the smooth diffuse reflection from the skin.

SHADOWS

While we are talking about light, we have to realize that the shadows created on, within, and by the subject of our photographs will be as obvious and potentially more important within an image than the light that creates them. Throughout our perceptual development and our photographic training we find that the first items of light and lighting that are discussed are normally the shadows.

To create a vocabulary that we can use consistently to discuss shadows in light and lighting we need to define the difference between a cast shadow, an area in the shadow, an area within an image that is darkened but not completely in shadow, and the dynamic transition from highlight to shadow.

The simplest description of the shadow is an area on the subject, within the subject, or adjacent to the subject that is darkened because an object or change in surface blocks the primary light

In this image we can see all the types of shadows. The distinct shadows were created by a specular light form. In this case, the light casting the shadows was a Fresnel spotlight. *Photograph by Tim Meyer*.

In this image, there are various LDE forms. With a large broad light source, the LDE on the bridge of the nose is sharp because of the rapid change. On the forehead, the LDE is softer because the shape has a gradual change.

The transition shows in the size of the LDE between the lit area and shadow.

source from fully illuminating the area. (The term *primary* is important here. In photography, we most often use the main light to establish the shadow structure for the photograph.) Within this description of a shadow we find cast shadows and shaded areas within a scene.

In a more scientific way, we can discuss an umbra (a completely dark area where no light from our primary light source enters shadowed areas) and a penumbra (a darkened [shaded] area in which light from the primary source has not been completely blocked). A shaded or partially shadowed area, not receiving light from the primary light source but not exhibiting the darkness of a shadow, is created when: (1) the light source is large enough that some of the light from the primary source is blocked and other portions of the light source are able to enter that area of the subject or shaded area or (2) ambient or non-primary light enters the area. (*Note:* In photographic terms, the second phenomenon is called *fill*. Fill happens in most situations naturally.)

This distinction between shadowed areas and shaded areas, umbra and penumbra, is one of the major differences between specular and diffuse primary light sources. This is because we describe light as traveling in straight lines. This means that if a light source is larger than a single point, there will be slight angular differences between the shadow created by blocking light from the lower portion of the source and that created by blocking light from the upper portion of the source. The umbra, then, is the shadow produced when an obstruction blocks the light from the upper *and* lower portions of a source. The penumbra, then, is the cast shadow area where only one part of the light source is blocked while the other part is unblocked, allowing angular components of the light to enter this area of the scene. This is the dynamic transition from lit to shadowed area. The transition shows in the size of the LDE between the lit area and shadow. The more light rays that spill over the shadow-casting object or surface change, the broader the LDE will appear.

COMPLEXITY OF LIGHT AND SHADOW

Renaissance painters often used a light style known as *chiaroscuro*. This dramatic approach called for a dramatic single light source, which normally originated at a steep overhead angle and created

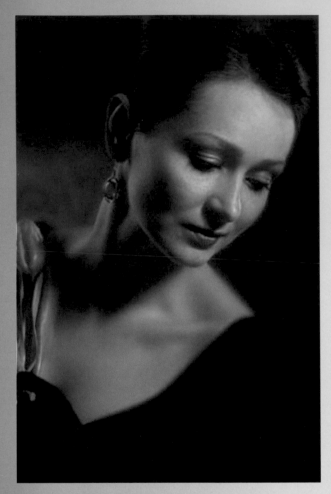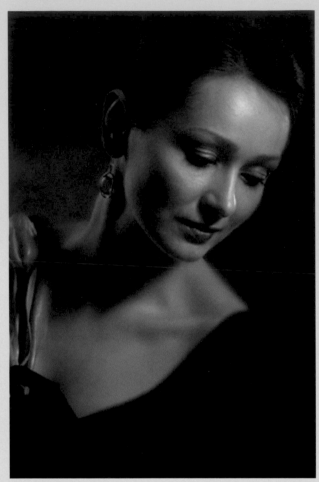

The image on the left shows the portrait with a feathered medium-sized white umbrella as the light source. As a more diffuse non-specular source, it creates more open shadows, a softer LDE, and less specular highlights. The lighting for the portrait on the right featured a more specular light source that darkened the shadows and produced a harder LDE. It also created a more complex specular highlight beyond just a singular white tone. *Photographs by Tim Meyer.*

bold, dark shadows. This produced a dramatic and contrasty look in the paintings. The advantage the painters had is that they could put detail into the shadow areas of the painting at their discretion. Photographers, however, must use lighting and exposure to ensure that detail will appear in areas of shadow.

Chiaroscuro is often shown as a point source light, generating light rays from a distance. As photographers, we normally do not work in singular point source lighting situations other than in bright clear-sky sunlight. Even in sunlit situations there is usually reflected light bouncing onto our subjects from the ground or nearby objects. When working in the studio or indoors we find

Chiaroscuro is often shown as a point source light, generating light rays from a distance.

ourselves working in situations with multiple light sources, or settings where we have controlled the light to provide fill to open up the darkest areas of the shadows so that detail can be seen. These situations and others can produce complexity in the highlight and shadow portions of the image.

The main light sculpts the subject, adding a three-dimensional feel in the two-dimensional photograph. The more specular the light, the more dramatic the sculpting of the subject will be. However, very specular light may not provide the ability to record detail or subtle shape because it produces dark shadows. By adding complexity to the shadow, we refine the structural elements that can be seen compared to using just specular light. Using fill of various types will build the complexity by creating differential intensities within the shadows.

Further, we often find that the highlight generation, particularly on semi-specular surfaces, can be quite complex. While highly specular surfaces will reflect all the light sources, providing light to the subject, and highly diffuse surfaces will blend and mix the light sources, semi-specular surfaces such as satin or moist skin can provide the base for building complex highlights. These surfaces have the advantage of increasing contrast from specular sources while smoothing the diffuse sources. This will produce specular highlights embedded within diffuse highlights.

> *The more specular the light, the more dramatic the sculpting of the subject will be.*

PERCEPTION AND LIGHT

There are many aspects of a picture that are involved in the perception and interpretation of the scene. For photography, light is a powerful controller of two crucial perceptual constructs. For our purposes in two-dimensional photography, these important constructs are (1) the creation of contour (the outer shape of the object) and (2) the creation of various amounts of perceived depth within the picture by the creation of and appearance of shadows and shading.

While volume, shading, color, etc., are all important in our final understanding of an object, it is the contour, its outer shape, that gives us the most important information about the object. When we think about camouflage, we can visualize how an interruption in our ability to see an object's contours can limit our ability to perceive the subject.

Carefully controlled light allows us to perceive a third dimension in a two-dimensional medium. *Photograph by Tim Meyer.*

Light and lighting play an important part in understanding the contour of an object in photography. Because we are talking about two-dimensional imagery, the contour increases in its importance. From the standpoint of lighting, the contrast between foreground and background creates the contour that we are able to see in the picture. If the intensity of light is controlled to create a noticeable difference between foreground and background, we will see the contour of the object. When the lighting creates equal values on the foreground and background with only a small amount of color difference, the contour of the object will become difficult to see.

The second construct where lighting is very important is in the perception of depth. Simply stated, parts of the picture that are brighter (i.e., have more lightness) tend to project forward and toward the viewer, while dark areas recede. This is even true when areas in shadow have differing amounts of lightness. With highlights, the effect of brightness is most noticeable in an image. Objects with bright areas of highlight will move forward, toward the viewer.

A secondary concept involving perception of depth and lightness has to do with the use of color within a two-dimensional image. Because color vision requires more energy, when color is perceived in an image the area of most saturation will tend to pull forward. This is because the human perceptual system equates the ability to see color with more energy (light) in the scene.

Last, light will create shadows and shading on the object and background. These cast shadows also create depth within an image beyond the effect of lightness. If the direction of the light is known, coming from any inferred direction in relation to the object, this can be perceived. The way the shadows are cast by the features of the object on itself or on the background creates great clues to depth in the image.

In this image, the light is brightest on the child. The sharp contrast between the skin tones and the dark surrounding draws the eye to the main subject. *Photograph by Tim Meyer.*

Objects with bright areas of highlight will move forward, toward the viewer.

he first consideration for this image was to balance the exposure of the light emanating from the Profoto Magnum with the ambient acklit daylight. It was understood that the sun would flare and create a star form. To control the Magnum's light pattern, a 10-degree rid was used. The attempt was to create an unnatural look. *Photograph by Tim Meyer.*

The top frontal lighting, known as Paramount lighting, was created with a 10-degree grid placed on a Profoto Magnum reflector. Using a grid on the background light enhanced separation in this low-key image. *Photograph by Tim Meyer.*

IN REVIEW

1. Regardless of light sources generate light, they all function the same. Unmodified, light radiates in all directions.

2. The Inverse Square Law states that light's intensity is changed as the source-to-subject distance changes. As the light source moves farther from the subject, the intensity is reduced. As the light is moved closer to the subject, its intensity increases.

3. The light's color bias is a function of how the light is created.

4. The subject's surface affects the way light will look in a photograph.

5. An edge is formed by a combination of the characteristics of the light and the surface type. Since the edge is changeable, it is defined as the light's dynamic edge (LDE).

6. Shadows result when the path of the light is blocked. The main light creates the shadow forms seen in the photograph.

7. Shadows can be "chunky" (when the lighting creates simple shadows) or "fat" (when shadows and highlights are created with complex multi-light setups).

8. The way light functions when making a photograph affects the perception of the final image.

SPECULAR LIGHT

3

When we consider light in photography, perhaps the most important element beyond its mere presence is its quality. As discussed previously, one of the major distinctions in the quality of light is its specular versus diffuse nature. It is easiest to start the overall discussion of light quality by dealing with specular light.

Right: This image shows strong specular lighting. *Photograph by Tim Meyer.* **Above:** This diagram shows the lighting setup used to create the shot.

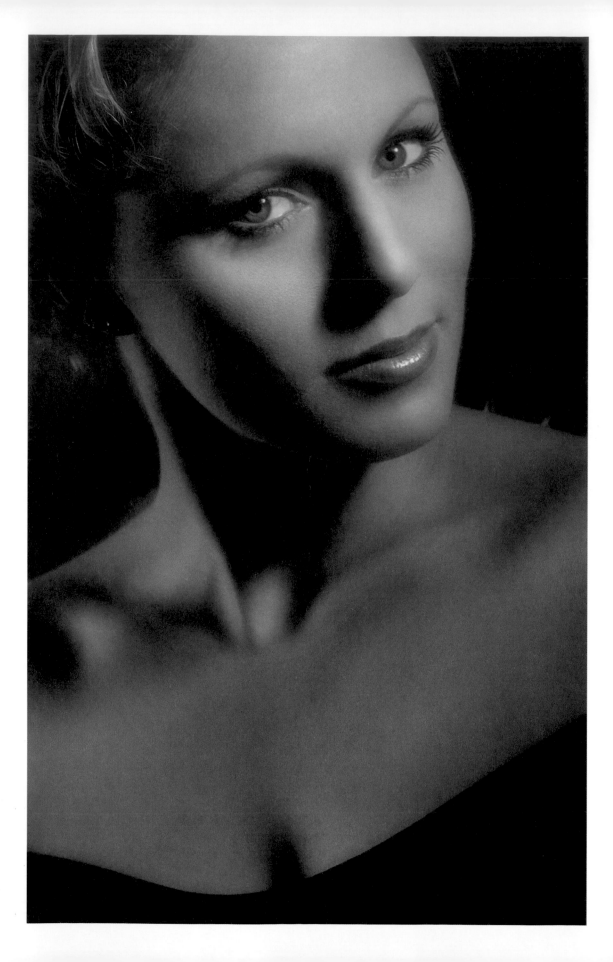

Above: This image shows the characteristics of specular light. The cast shadows are dark and full. The LDE is abrupt whether it is created by an obstruction such as the bridge of the nose or a change in shape on the side of the cheek. The highlights are also sharp and bright.

Facing page: The specular look of this image was produced with a Fresnel spotlight from above on the right and a vertical strip softbox positioned vertically from the left rear. A gridded reflector was used to illuminate the background. *Photograph by Tim Meyer.*

Perhaps discussing the specularity of light as angular components of light rays themselves makes the most sense in understanding how we can modify the quality of the light. We can think of light coming from a single point as being completely specular. If it were possible to create a light source that radiated from a single point, an infinitely small point, then we would be creating specular light everywhere that the light source illuminated. This is based on our using the concept that light travels in straight lines. If the light radiates out from a single point, all light rays would be at divergent angles with all other light rays from that source. In this way, no two light rays would ever cross. Therefore, the light illuminating any single part of the subject would have only one angular component. When light striking the object to be photographed has few angular components it is specular.

Even though this book is about light modifiers that we might use with artificial light, since we are so familiar with how sunlight changes appear in various situations, we will explain some of the basics of light quality with light from the sun.

In defining the angularity of the light, distance is involved. For photographers, the most common light source is the sun. While the sun itself is quite large, by the time the light arrives on the Earth's surface, the intervening distance has reduced the number of light rays' angular components to very few and mostly parallel to each other. For this reason, the light from the sun on a clear day will be very specular. Likewise, any single light source that travels across sufficient distance will create specular light.

HIGHLIGHTS AND SHADOWS

Specular light has specific characteristics that are quite apparent. Primarily, specular light has a hard look and tends to have a contrasty effect on photography. When we think of the hot burning sun, we are picturing the effect of specular light in the environment. We see this for two primary reasons on or about the subject. These are the highlights that are created when reflected from the subject and the shadows that are generated on the subject and by the subject.

Depending upon the surface, specular light creates small intense areas of illumination. While a diffuse surface will spread the effect of the light across a larger area, the intensity of the light will be seen as a hot spot even if it is only slightly brighter than

the surrounding area. When a specular light illuminates a specular surface, the effect is a hot spot reflection that has a drastic falloff of intensity to the areas around the hot spot. With semi-specular surfaces, such as moist skin or satin, specular light creates moderate hot spots with smoother falloff of intensity. With specular light, the surface that the light interacts with has a large effect on what the highlights will look like.

In considering the creation of shadows by specular light, the concept of light traveling in a straight line provides the easiest explanation of the characteristics of the shadows. If for a moment we returned to the concept of a point source light where the light rays do not cross each other, we know that when the light rays reach an object they are stopped completely; if the rays do not interact with an object, they continue on their straight path. In this way, the light is either stopped or continued. When the specular light rays make impact, the object highlight is created. The effect of the light reflects from the object and is recorded by the camera. On the other hand, when the light misses the object, it does not illuminate the object and cannot be captured by the camera. This means that, in a pure sense, an area away from the point source light, having the light blocked, will have no illumination reaching it.

In a purer specular light situation, with no fill light or ambient light available to illuminate areas not directly affected by the light source, the shadows generated will be very dark. Beyond the darkness, considering a point source light as our optimal specular source, the shadows will be crisp. A crisp shadow will have a very delineated LDE. Therefore, the shadows created by specular light are very well defined, hard-edged, and dark. These are primary characteristics of specular light.

If we consider the entire frame, including the background, as the image, we will also notice that the same shadow-generating characteristics happen in all areas of the image. Therefore, shadows that fall on the area surrounding the object or into the background will also be dark. Further, the more specular and therefore the less angular the light rays from the light source, the crisper the shadows will appear.

Shadows that are cast by specular light will have the same characteristics within and on the subject. However, one additional

The shadows created by specular light are very well defined, hard-edged, and dark.

Photograph by Tim Meyer.

This image shows the effect of the beam structure of the light source and the shadows produced. Here, a silver parabolic reflector was used from a reasonable distance. The output from the reflector created a well-defined beam of light, as seen on the wall, and the parallel light rays created specular shadows that are crisp and dark on the subject and wall. *Photograph by Tim Meyer.*

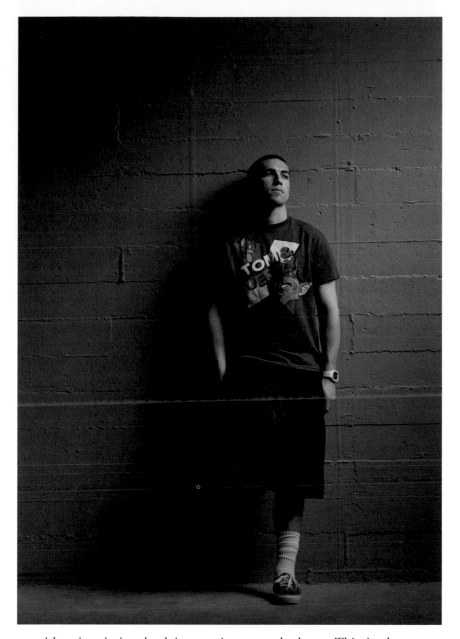

If our hand is a short distance from the wall, then the shadow will have a strong, crisp LDE . . .

consideration is involved in creating cast shadows. This is the relational difference between the object casting a shadow and the surface on which the shadow is seen. If for a moment we consider a shadow cast on the wall by our hand, the crispness of the shadow will depend upon how far our hand is from the wall as well as how far the light source is from our hand. The closer our hand is to the wall, the crisper the shadow. With a specular light, if our hand is a very short distance from the wall, then the shadow will have a very strong, crisp LDE and little or no illumination in the shadowed

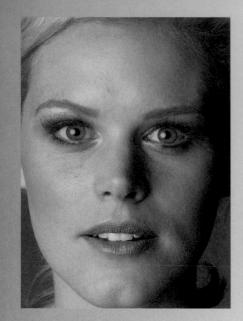
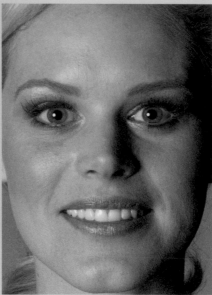

These two examples show the effect of distance on the creation of both shadows and highlights. Both were made with a Profoto 5-foot Octa. As shown in the far-left image, with the modifier 5 feet from the subject (the diameter of the Octa), the light is diffuse with the LDE showing smooth transitions from highlight to shadow, and the shadows are open. When the Octa is used at 10 feet from the subject, the LDE is more abrupt and the shadows appear much darker. The highlights show a similar change; they are spread out with the light at 5 feet and much more defined and brighter when the light is 10 feet from the subject.

area. If we then move our hand away from the wall, the LDE will soften and the darkness within the shadow will brighten.

The reasons that the LDE is not always as crisp as possible with specular light comes from the light itself, the way the light is scattered in the air, and from the shadow-catching surface. It also potentially comes from the light wrapping around the edge that casts the shadow.

First, most lights that we use are not pure point sources. The light sources themselves have a larger surface area than a single point. This means that the light rays generated from this type of light will have some angular components that can create a penumbra (a lesser shadow). Even the sun on a clear day has a dimension approximately the size of a dime held at arm's length. While this is not a large amount of dimensional difference, it is enough dimension to allow a slight penumbra to be formed when the shadow-casting object is moderately close to the surface catching the shadow. Within the studio, a light source such as a spotlight will still have a light-surface dimension large enough to create a slight penumbra. Second, humidity or particles in the air can scatter light, allowing some light to have more angular components as it interacts with the shadow-casting edge. Last, some edges on a specularly lit object will cause the light to diffract slightly (bend around the edge) creating a softer, diffuse LDE.

Facing page: An octabox was used from a greater distance than usual. This produced a more specular look to the lighting, creating more distinct shadows. Using the octabox in this way produced a light with a strong LDE, while still keeping the shadows from becoming too dark. The border and graphic elements were added in postproduction. *Photograph by Judy Host.*

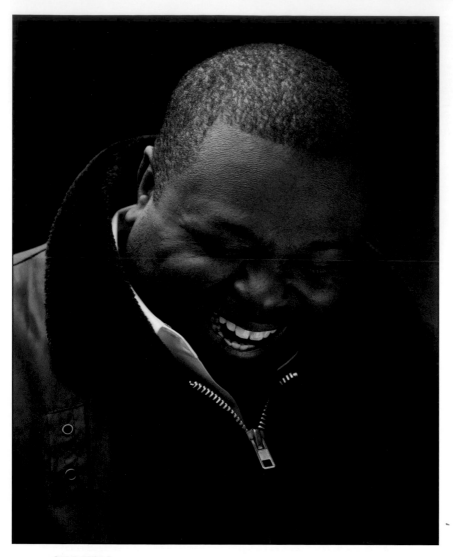

IN REVIEW

1. The specular/diffuse nature of light is normally the first quality of lighting control used.
2. Specular light is achieved when few angles of light from the light source reach the subject.
3. The farther any light source is from the subject, the more specular the source.
4. Specular light looks hard, with bright highlights and dark shadows.
5. It is the specular portion of any light source that sets the shadowing of the subject. The LDE with speculuar light will be crisp.

SHAPING

Specular light, or the specular component of diffuse light, is the primary shaper of the photographic subject. The concept of a specular complement is mentioned here because with very few exceptions, all lights have both specular and diffuse portions of their beams.

Specular light shows directionality better than diffuse light because it has fewer angles of light included. It is this directionality that does the primary shaping of an object by setting the highlights and shadows that are created on or in relationship to the object. While the diffuseness of light fills in and lightens shadowed or shaded areas, it is the specular components of the light that are blocked, creating the shadows and shaded areas.

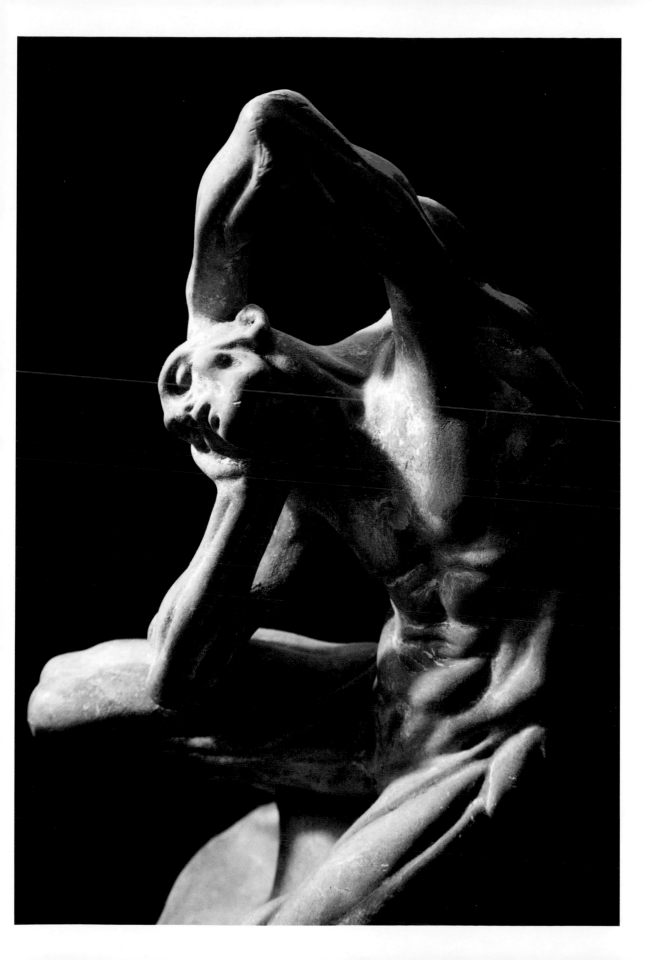

4 DIFFUSED LIGHT

In the previous chapter, we looked at one end of the quality spectrum, specular light. Here we will look at the other end of this continuum, diffuse light.

Just as with specular light, to understand diffuse light, we need to examine the angular components, the light rays coming from the diffuse light source. Rather than thinking of the light coming from a single point, we can think of a diffuse source as being made up of many points of light. The light quality created by many radiating light sources creates diffuse light. Whether the points of light are separated or adjacent to each other, the light generated

An octabank created broad diffuse light that softened the look of the image. *Photograph by Thomas James.*

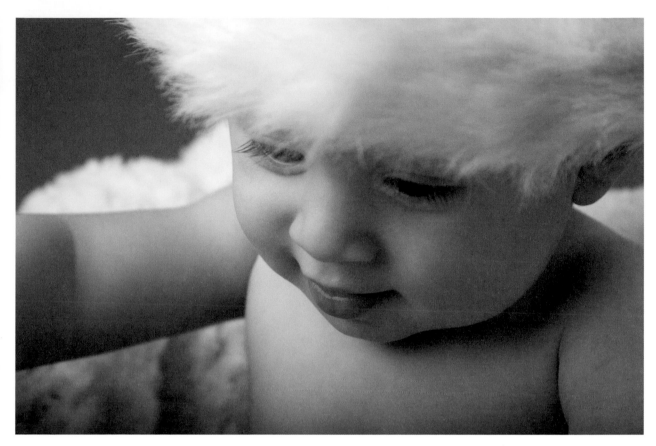

Working with infants means that the normal directions that can be given to the subject will not get the reactions you want. Therefore, simple lighting setups tend to give better results. Also, diffuse light renders the softness that is associated with babies' skin and roundness of form. For this image, a large softbox produced light from the left side, and fill was provided by a strip softbox. This allowed for a large pool of light where the infant could move, allowing reaction to the moment without worrying about the subject moving away from the designed lighting. *Photograph by Allison Flowers.*

The surface size of the light source is one of the key elements in creating diffuse light.

produces numerous angles of light rays reaching the photographic subject.

The surface size of the light source is one of the key elements in creating diffuse light. It is important that we think of the lit surface. If a large surface is lit, then each part of the surface acts as a point source creating radiated light. Therefore, the larger the lit surface, the more radiating points and the more angles that the light from that source will reach the subject. With more light angles reaching the subject, we have diffuse light.

While the size of the lit surface matters, so does the distance of the light's surface from the subject. Regardless of the size of the surface of the light source, the greater the distance, the fewer angles of light can reach the scene. As previously discussed, the

sun's surface is quite large, but because of the great distance, few angles of light reach the Earth. Thus, sunlight on a clear day is specular.

However, when the light from the sun passes through cloud cover, the light is scattered and the new light surface is the lower side of the cloud. The thicker the clouds, the more the light will be scattered and spread across the clouds. The effect of the cloud thickness is to disrupt the specular beam structure of the light. As the beam is spread across a larger area, the light becomes more diffuse. Therefore, the amount of scatter is an issue in the creation of diffuse light.

Also, the size of clouds spreading the light makes a difference in the amount of diffuseness of the light. As the surface of the clouds broadens in relation to the scene, the specular light from the sun is spread out across the cloud, and this creates diffuse light. When thick clouds cover to the horizon in all directions, the light becomes maximum diffuse light. This means that the light reaching the scene is from all directions, at its maximum angularity and diffuseness.

HIGHLIGHTS AND SHADOWS

Diffuse light's characteristics are obvious. Its most commonly discussed characteristic is that the light is soft. A longer range of the light (less contrasty) and the open shadows created by the light entering the shadow areas from the many angles in the diffuse light produce this soft feeling.

Just as the shadows are weaker with diffuse light compared to specular light, the highlights are also subtle. Diffuse light has a less defined beam and therefore spreads the highlight across the surface rather than concentrating it.

When diffuse light falls on a diffuse surface the light spreads evenly, giving a smooth illumination with gradual changes in intensity. Surface irregularities are minimized with diffuse light because it has less defined highlights and weak shadows. For this reason, diffuse light is a popular choice for portraiture with its softening effect on the subject and reduction of skin blemishes.

Diffuse light illuminating a specular surface results in the creation of a reflection that shows the shape of the light surface. Both the shape of the light surface and the shape of the reflecting surface

This image shows the characteristics of diffuse light. The cast shadows are soft and weak. The LDE is gradual and often does not even have a distinct edge. The highlights are very weak and look like lighter areas unless the surface is specular (when the light will take on the shine of the surface).

Facing page: To create this image, Judy Host first lit the model with the idea that she would be layering the textural material into the image in postproduction. She placed an octabank above the camera as her only light. Positioning the octabank in this manner created flat lighting, which allowed the makeup on the model to define her features.

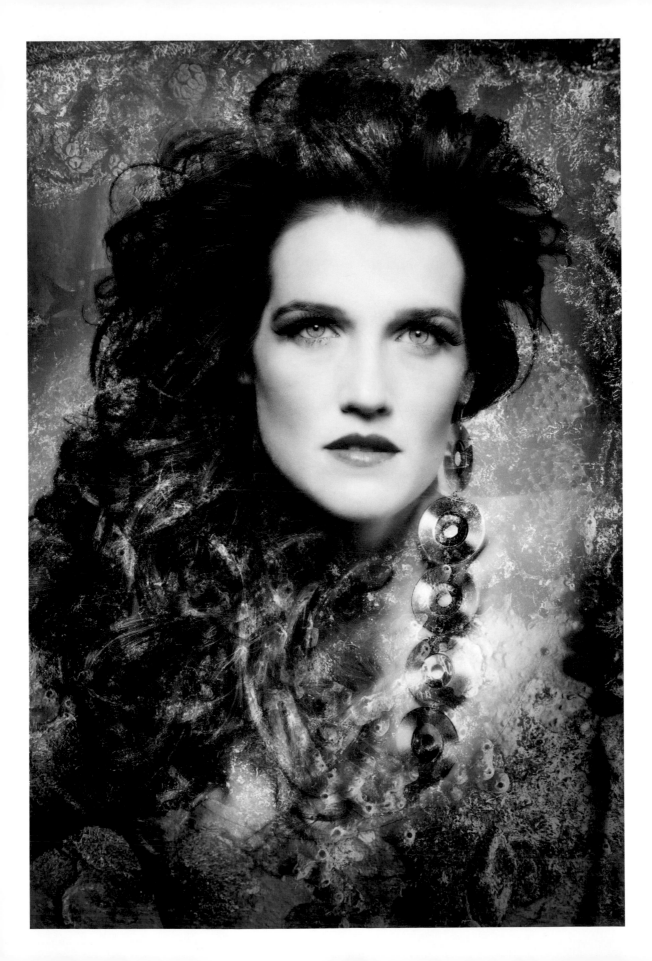

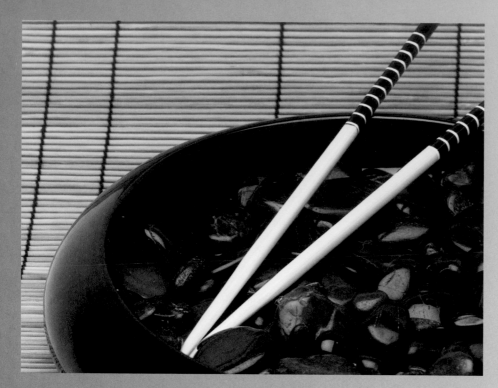

Here, the surface's effect on the way the light source is seen is evident. On the background mat and hashi (Japanese for "chopsticks"), the diffuse light is spread by their diffuse surfaces. There are no noticeable highlights and abrupt shadows. However, on the specular surfaces of the polished pebbles and black-glazed ceramic bowl we see distinct reflections of the diffused light source or the lighter-toned mat. There are no complete shadows seen in the image, just reflections from the specular surfaces of other dark parts of the set. *Photograph by Glenn Rand.*

will determine the resulting shape of the highlight on a specular surface. The more mirror-like the specular surface is, the greater definition will be seen in the reflection of the light surface. Also, the closer the light surface is to the reflecting surface, the larger the shape reflection will appear. (As will be discussed later, round or octagonal softboxes are used to give less jarring catchlights in the eyes of a portrait subject.)

Diffuse illumination of semi-specular surfaces produces broad highlights with smooth transitions to very weak shadows. Here, the smoothness of the surface and the great number of angles of the light reduce the transitions from highlight to shadow.

In a purer diffuse light situation, with no fill light or ambient light available to illuminate areas not directly affected by the light source, the shadows generated will transition from a weak shading to dark. This means that the shadow will look soft, producing the overall feel of the lighting. This shadow will have a weakly delineated LDE. The more diffused the light, the less defined the LDE to the point that when there is a wraparound light, such as with complete overcast, the edge will disappear. Therefore, the

The shadows created by diffused light are less well defined than with specular light.

shadows created by diffused light are less well defined than with specular light—they are soft-edged and open. These are a primary characteristic of diffused light's shadows.

With diffuse light, looking at the entire picture, the image will look flat because shadows are weak and the only contrast in the scene will be subject dependant. This makes diffuse light particularly helpful in producing high-key imagery.

Cast shadow with diffuse light is an issue of the amount of penumbra or the amount of light that can enter the shaded area. With a large light surface near the object casting a shadow, the shadow will have a very soft LDE. As the light surface gets larger in relation to the shadow-casting object, the shadow will disappear. This approach is used by some photographers who place their camera close to a large light surface to remove the potential of casting their own shadow into the scene.

SHAPING

Diffuse light refines the shape created by the specular components of light. While the specular elements of lighting, particularly direction of light, sculpt the shape of the subject, the softness of diffuse light smooths and adds volume to the subject. The openness of the diffused light provides details in the shadows and smooths the transitions between highlight and shadow. This produces more information in the image and a fuller rendering of the subject.

It must be understood that diffuse light has some specular characteristics unless the light evenly surrounds the subject. In a

When you compare the details of the specular light on the left and the diffuse light on the right, you can see an extreme difference in shadows and LDEs.

controlled lighting environment, the size and the distance of the diffused light's lit surface from the subject will control the amount of diffusion and the contrast on the subject.

In this image, the shaping of the knives, wood, metal, and leather parts of the set are shown by the way they are illuminated by the diffused light. The scabbard and handles of the knives are given a smooth roundness by the gradual LDE, indicating the curve was from the diffuser screen. Since the screen was purposely lit with a light pattern, the reflections of the light source in the blades of the knives shows this subtle tonal play. Each blade is maintained at a different angle to the light, creating smooth lighting on the large knife and an accented lighting on the smaller hand-wrought blade. The map in the background has a diffuse surface that accepts the diffuse light more evenly with only distance away from the source and small soft shadows diminishing its intensity. *Photograph by Glenn Rand.*

IN REVIEW

1. Diffuse light is one that has many angles from the light source reaching the subject.

2. Larger light sources are more diffuse than smaller sources.

3. The farther a large light source is from the subject, the less diffuse and more specular the light characteristic.

4. Diffuse light looks soft with weak highlights and shadows.

5. The LDE with diffuse light will be soft.

BEAM MODIFICATION

5

At the beginning of any discussion of light modification we must deal with how to control the source of the light in such a way that we can modify it to suit our purposes. As stated earlier, light is a radiant energy source. This means that light's natural tendency is to spread out in all directions. With very few exceptions, this is not desired in controlled light situations. So

This image gains its power from the Profoto Magnum reflector. The reflector created a beam of light that illuminated the model's upper torso and head without spilling light below her waist. Using a grid on the Profoto Magnum tightened the light's beam, controlling the spill of light onto the draped fabric. We can see the translucency of the fabric, which was backlit by accent lights. *Photograph by Tim Meyer.*

the first modification and the one that is common to most light modification systems is the control of the source to create a beam structure.

REFLECTORS

With most lighting equipment, the primary restriction of the radiant energy of light is some form of a reflector. This might be built into the equipment or added to the equipment to create certain characteristics of the beam.

Three factors enter into the efficiency of any reflector: the shape of the reflector, the surface of the reflector, and the relationship of the light source to the reflector.

SHAPE

With few exceptions, lighting equipment uses some form of reflector to direct the light. In some cases, the reflector is part of the light unit, while in other situations the reflector is part of the modifier. In terms of modification of the light beam, it is important that a reflector directs the light either from the light unit or toward the proper location for the modifier.

We can think of reflectors as having one of five common functional shapes. The first of these shapes is relatively flat. A flat reflector stops light from radiating backward from the light source, away from the subject to be lit. In some cases, reflection of the light's energy into a beam is not the purpose of a flat behind the light source; instead, it is used to keep light from radiating backward and thus illuminating objects or surfaces that you will

We can think of reflectors as having one of five common functional shapes.

Left: The Profoto 7-inch grid reflector's polished conical surface is very efficient in directing the light from the source through a grid that will be mounted on the front of the unit.
Right: The Profoto Disc is a basic reflector that is used to direct the light away from the light source. Its small size provides a specular light quality.

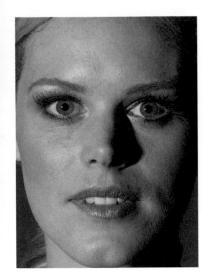

The Profoto Disc creates a hard-edged LDE with dark shadows.

This reflector structure will create specular light—a contrasty look with a very crisp LDE.

want to be dark. Depending upon the size of this reflector, the amount of light radiating toward the back or away from the subject will be controlled. The larger the reflector, the less light will reflect backward. This structure has a very weak beam that is enhanced only by the fact that some of the energy from the light is redirected forward. This is often the structure that is used for primary light sources that will be further modified. If used in this fashion without further modification, the light will take on what is known as a bare-bulb look. This reflector structure will create specular light—a contrasty look with a very crisp LDE. While this reflector structure may be a part of a basic light source, it is often augmented with additional reflectors that further modify the light's characteristics.

A second form of reflector is angled up and away from the light source. Perhaps the most common of this type of reflector is the conical portion of an incandescent floodlight's bulb structure. This portion of the light is coated with a metallic material that reflects the light through the front lens of the bulb. For the most part, angled reflectors—whether conical or flat-folded angles, with no other modification—create a broad pattern of light similar to the angle and shape of the reflector. Because the pattern fills a large area, these are referred to as *floodlights*. They have a very large beam structure with fairly even lighting across the beam. However, there will tend to be a more intense center section of the beam and, depending upon the amount of angle and surface on the reflector, the falloff from the beam may be distinct or gradual. The light shining on the subject from this type of reflector has all the characteristics of any specular light—a crisp LDE with contrasty highlight-to-shadow ratios.

For the most part, this type of light is used to "pool" light, making large, broad patterns of fairly even illumination. Because of the way the light tends to fall off from the central beam, these lights can easily be overlapped to create very large, evenly lit areas.

The next two reflectors, spherical and parabolic, may appear quite similar at first glance. The difference is the mathematical shape of the reflecting surface. A spherical reflector is constructed by using a portion of a sphere, equidistant from a center point. A parabolic reflector is in the shape generated from a mathematical formula so that the light reflected from any point on the reflector

surface will travel in parallel rays if the light source is at the mathematical focus of the parabola. The slight difference in shape can create a vastly different beam structure.

With a spherical reflector, the light will have a central beam and fall off to a broad light pattern. Depending upon the position of the light source within a spherical reflector, this falloff from the central beam can be quite abrupt, creating a central beam with a diffuse light surrounding it. A parabolic reflector will have a much more concentrated central beam with an abrupt falloff. If the light source is placed precisely at the focus of the parabola, the light generated from this reflector will be collimated (traveling in a consistent column).

The parabolic reflector surface generates a much more specular light compared to the spherical reflector. Therefore, the LDE on the subject lit by a parabolic reflector will be more defined than the LDE created with the use of a spherical reflector. Also, the highlight from a parabolic reflector will be more intense and better defined.

Both spherical and parabolic reflector concepts are used in the construction of photographic umbrellas. These two types of umbrellas and specialized large reflectors will be discussed in depth later in the book.

The last reflector to be discussed here is what we will call a back-reflecting device. This is a reflector that is part of a light fixture designed to reflect the light source to the back of the unit

Both the Profoto Narrow Beam and the Narrow Beam Travel reflectors are shallow parabolas that create a small, tight beam of light (32 degrees). The beam is concentrated, with only a small amount of spread coming from the light source being open to the subject. The light is harsh with a strong LDE and rapid falloff away from the beam.

With a spherical reflector, the light will have a central beam and fall off to a broad light pattern.

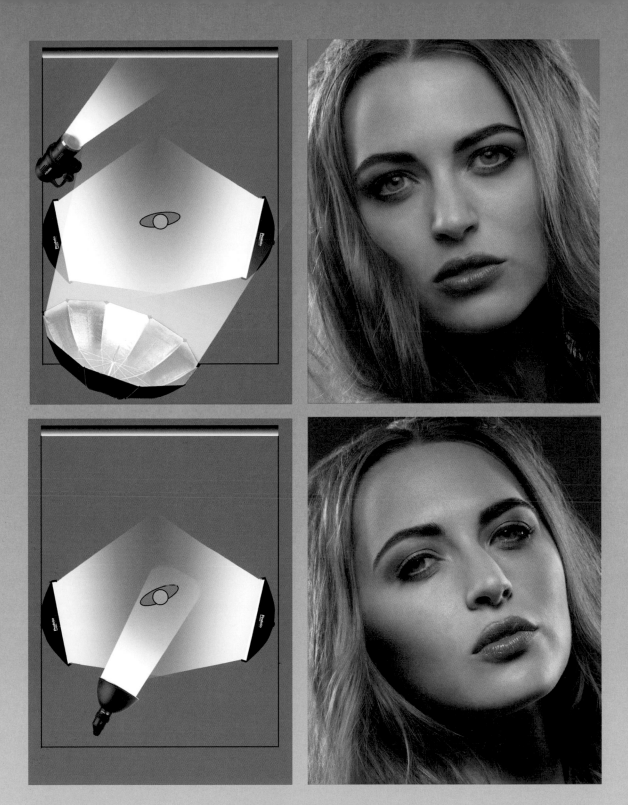

While a monoblock was used for background illumination for the top image, no background illumination was added for the lower image. Two 1x6-foot softboxes on either side of the model served as accent lights, providing rim lighting. Fill was from behind. The difference in the characteristics of the lighting was due to the use of a 7-foot umbrella for the top image and a Profoto Magnum with a 10-degree grid for the bottom image. The 7-foot umbrella produced a softer main light and projected some light onto the background, bringing up its tone. For the bottom image, the specular light from the gridded Magnum produced a crisp lighting. The Magnum creates a near-collimated light, so its illumination does not bring up the background tone and only illuminates select parts of the model. Also, the higher contrast of the specular light makes the accents more visually active in the image. (The image that began this chapter used the same light setup as the second image.) *Portraits by Tim Meyer.*

where it is then reflected by another form of reflector toward the subject. Unlike the other reflectors just described, this reflector does not affect the light falling on the subject as much as the rear reflector or farther light modifiers. These are particularly useful in creating collimated light, whether through a lens or reflected off of a parabolic reflector.

SURFACES

A second major consideration in the design, construction, and use of reflectors to modify the beam structure of lighting equipment is the surface of the reflector itself. While the majority of reflector surfaces are brushed metal, they vary from highly polished surfaces, to pebble surfaces, to painted surfaces.

The purpose of the various surfaces is to either concentrate or scatter the light rays in the beam. The higher the polish on the reflector surface, the more concentrated the light. The more irregular the surface, the more the reflector will scatter the light.

Ordering the reflector surfaces from smoothest to most irregular, we start at a highly polished surface. These mirror-like reflectors are used as both primary and back-reflecting reflectors. Since they very precisely reflect the light, they create a distinct beam that can be focused (primary reflector) or applied in a specific pattern (back-reflecting reflector). When a polished reflector is made in a parabolic form, it has the ability to focus the light.

White and metallic surfaced reflectors, regardless of reflector type, are the most common reflector surfaces. A metallic surface will create a more controlled beam structure than a white reflector surface. Metallic surfaces can range from brushed or fabric texture to highly polished.

Brushed-metallic-surfaced reflectors also are good for creating a controlled or concentrated beam. While not as efficient as a polished surface, the brushed metallic surface loses little compared to polished reflectors. A slightly more rough metallic surface such as the metallic-coated fabric used in softboxes and umbrellas produces a well-controlled beam across a broad area.

The purpose of a white surface is to diffuse the light slightly. The scattering power of a white reflector depends on the size of the reflector and its proximity to the subject. Beyond white painted or metallized surfaces, lightly textured surfaces are used

Facing page: The beauty dish gives a directional light with a moderate LDE, allowing the sculpting of the body forms. Here, a horizontal strip light was used as an accent. *Photograph by Thomas James.*

The higher the polish on the reflector surface, the more concentrated the light.

A large American flag was used as a diffuser panel for this image. The flag above was angled down to the top of the image. The light coming through the white stripes provided the light for the exposure. The highly reflective surface of the flatware reflected the flag above. *Photograph by Glenn Rand.*

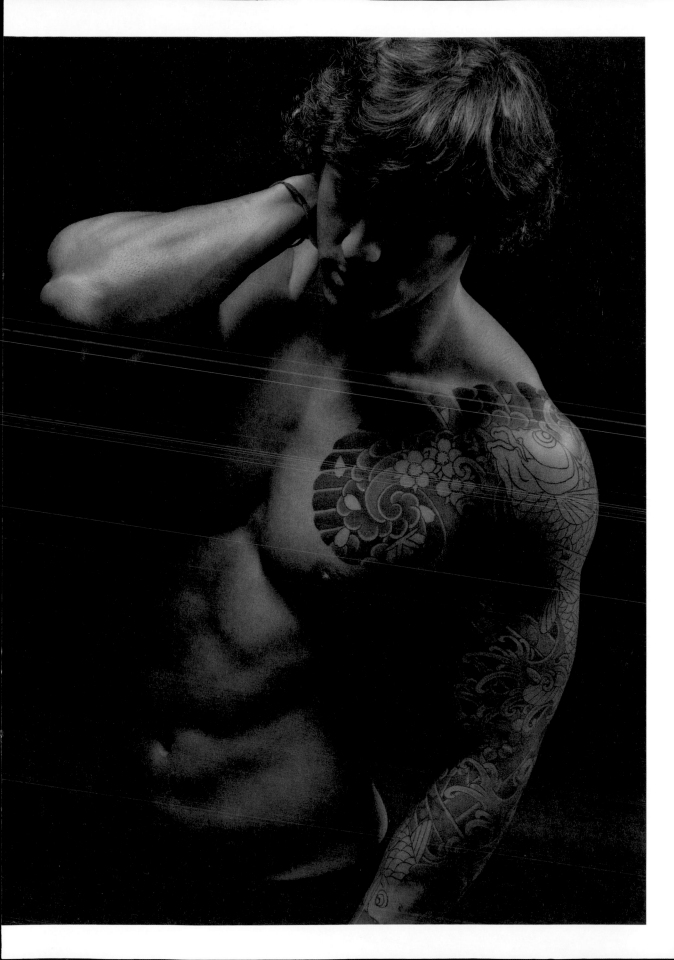

for the same purpose. These reflectors will spread the light to a large area beyond the beam that might be expected from the same shape if the surface is either polished or brushed metal.

Finally, a rough or pebbled surface on a reflector produces the most disruption to the light's beam. This surface is commonly used for broad-patterned light such as floodlights.

SOURCE PLACEMENT AND DIRECTION

The placement of the source in relation to the reflector has a great effect on the light beam. With deep reflectors (i.e., reflectors with reflecting surfaces that extend beyond the source position), as the light source is placed farther into the reflector structure, the beam becomes narrower. The portions of the reflector extend beyond the source to create shadows around the unit, and reflections of the light are at smaller angles from the reflector. The light is usually formed with a pronounced central beam created by the reflections

These two cut-away illustrations of a Profoto TeleZoom reflector show how similar radiant light rays will react as the source is positioned at different points within the reflector.

The three reflector shapes provide the capacity to adjust the beam's spread. The first is Profoto's Standard Zoom reflector, which is adjustable to create a 65 to 110-degree beam. The middle reflector is Profoto's Wide Zoom reflector, which adjusts to produce a 40 to 70-degree beam. Last is the TeleZoom reflector, which is adjustable to produce a 5 to 30-degree beam.

from the deep reflector and direct light from the source, and a less intense secondary area of light is created by light scatter from the reflector and the penumbra from the edge of the reflector.

With parabolic reflectors, the positioning of the light source changes the beam a great deal. A pure parabolic reflector will produce collimated light if the light source is at the focus of the parabola. As the source is moved from the focus of the parabola, the beam will either spread and become conical or focus on a point in front of the reflector. When a parabolic reflector system uses a back-reflecting unit or rear-directed light source so that the light is only illuminating the parabolic reflector's surface, you gain the most control of the beam. If the light source is open to the subject then, even though the beam will be controlled, there will be illumination spread beyond the beam.

Even with spherical and folded reflectors, moving the light source in relation to the reflector will change the beam's angle of spread. This allows for moving the light sources or moving the reflector to provide a zooming ability for the unit.

There are two other specific types of reflectors that have wide acceptance: the Magnum reflector and the beauty dish. The Magnum reflector is a relatively deep parabolic-based form with the light source within the reflector. It has a brushed metallic surface. Because of the form and depth of the reflector, it produces a strong beam with only a small amount of spread. It

> *With parabolic reflectors, the positioning of the light source changes the beam a great deal.*

produces a powerful specular light with a strong LDE and deep shadows.

The beauty dish is a specific type of reflector that creates a beam that is noticeably directional and slightly diffuse depending on the distance from the subject. It is primarily flat or near flat with raised, short conical edges. The LDE is distinct but softer than other reflectors. The dish is used in two different configurations. The first uses a back-reflecting unit over the light source. This creates a softer light than the beam from a beauty dish with either an open light source or a light source under a clear cover. The beam has a diffuse outer portion with an embedded specular component. When the back-reflecting unit is used with a beauty dish, it can cause a double shadow.

The last of the three specific reflector types is designed to work with ring lights. These reflectors are designed to take the light that encircles the camera's lens and, using a back-reflecting ring, send the light off a reflector to create a specific beam on axis with the camera's lens.

Because the beams from these reflectors are on axis with the camera, there are few if any shadows on the subject within the beam. However, since the light encircles the lens, it creates an "anti-halo"—a reduced light pattern or shadowing around the subject. This shadowing effect is more noticeable with an underlit background.

The beam has a diffuse outer portion with an embedded specular component.

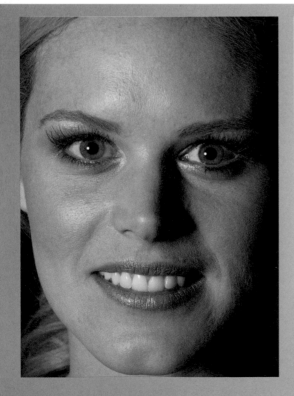

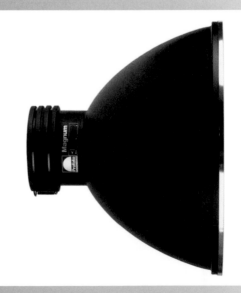

Above: The Profoto Magnum reflector is not actually a focusing reflector but allows the light source to be adjusted, changing the look of the light on the subject. The light from this reflector has a distinct LDE.
Left: The Profoto Magnum reflector provides an open directional light. The LDE is well defined but less harsh than a bare bulb.

and bottom left: The
...oto Softlight Reflector
...e 65-degree beauty
... (top) is traditionally
... with a back-reflecting
... It creates a directional
...ofter light beam.
...DE from a beauty
... is moderate to soft
...nding on the distance
...e reflector from the
...ect. The Softlight
...ector Silver 26-degree
...ty dish (bottom)
... a smaller size and
...ned metallic surface.
...oduces a harder light
... with a crisper LDE.
...t: The light beam from
...auty dish is broad and
...ctional. This produces
...t but relatively distinct
... with semi-specular
...d highlights.

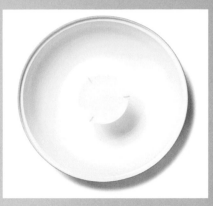

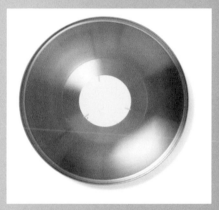

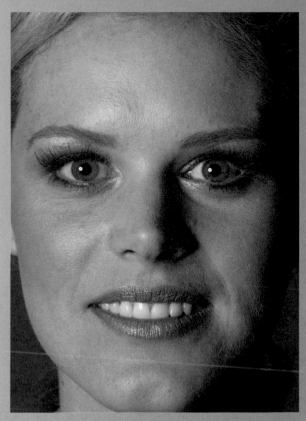

...PR Softlight Reflector is
...gned to work with a ring
... and create a beam of
...er light that is coaxial with
...ens of the camera.

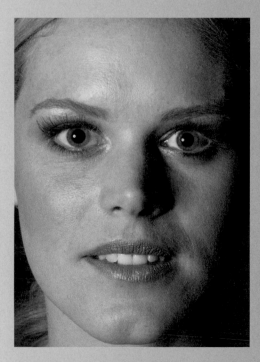

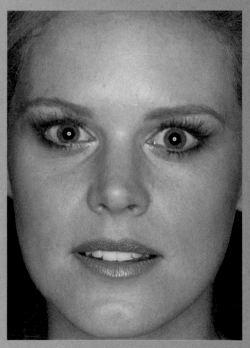

The ring light, as seen in the left image, is somewhat specular when used off the camera, but it is designed to be mounted on the lens axis, as seen in the right image. When on axis, the specular nature of the light can be seen with no shadows, and the highlights are centered on the model's features.

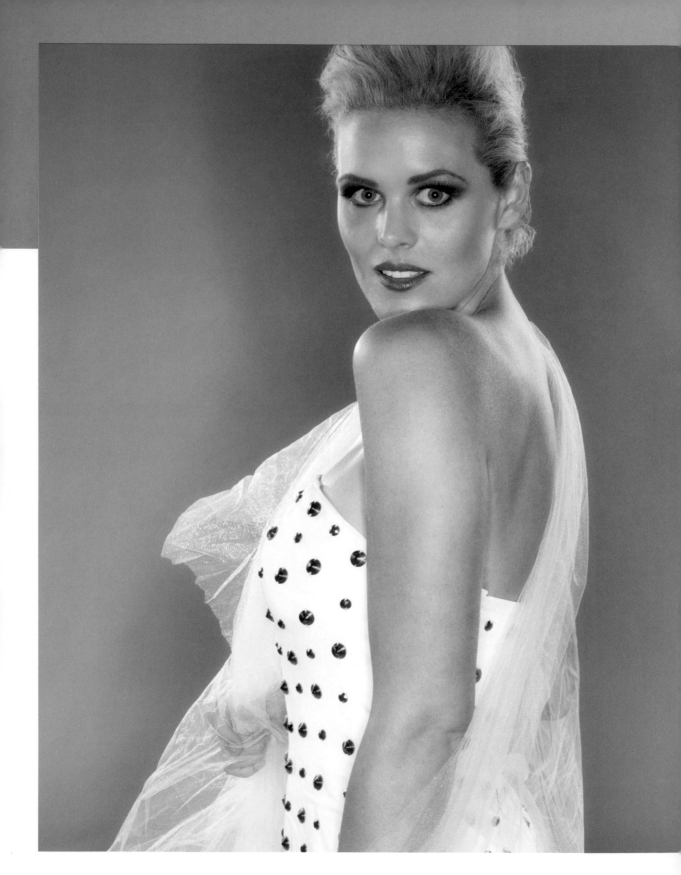

Facing page: On-lens-axis lighting—along with the hatchet lighting and the distance of the model from the background—created the edgy look in this image. *Photograph by Tim Meyer*. **Right:** The key to this image is the use of a Profoto ProRing with a PR Softlight Reflector as the main light. With the light on the camera axis, the specular highlights created falloff on the meridians of the arm and face. Also, the ring light created an anti-halo on the background (a shadow on the right side of the model created by the offset of the ring on the left side of the lens and on the left side from the right-side portion of the ring flash). Finally, two 1x6-foot softboxes were used to create hard accents on both sides of the model. These accents gained impact because of the anti-halo around the model.

CONTROLLING BEAM SPREAD

Because light is a radiant energy source, one issue that will always be involved with modification of the light used in photography is the control of how much the beam of light will spread. Beam spread happens naturally because light radiates. There are two main methods for modifying light to control the spread of the beam—the use of a light channel and lenses.

A light channel is a restrictive device that allows light to travel through a specific path only. In some cases, this path is small; in other situations, it can be larger. The most commonly used light channeling devices are grids, which are modifiers that contain a pattern of small, short parallel structures that can be put in front of a light source. Effectively, the grid breaks up a larger light pattern to create a grouping of very small lights with the spread restricted by the small channel the light has passed through. While not always the case, a grid's channels are often a pattern of interconnected hexagons. This pattern is called a honeycomb because of its similarity to the structure that honeybees create in their hives.

Grids control the spread of the light's beam with short walls around these small openings. Because the grid structure is made up of many very small openings, the depth does not need

While not always the case, a grid's channels are often a pattern of interconnected hexagons.

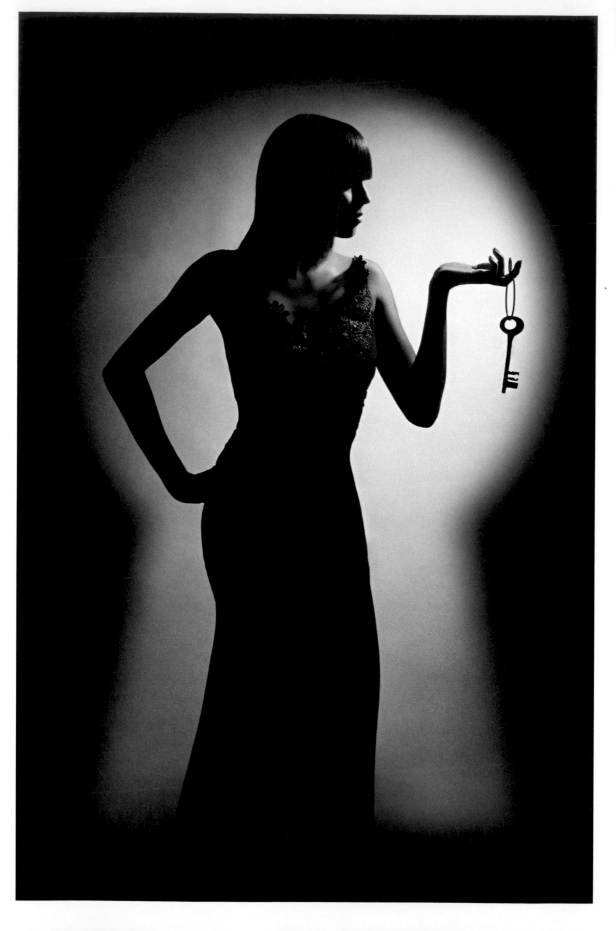

to be great in order to channel the light. The geometry of the grid structure creates a maximum angle that the light can travel through the opening. This angle is defined by the maximum diameter, or measurement across the opening, and the depth of the grid. The thicker the grid, the smaller the angle for any given size of opening. The smaller the angular measurement, the smaller the spread in the beam.

Grids are attached in front of the light, reflector, or other modifier. This means that the light travels through the grid as its last modification before traveling to the subject. The effect of the grid creates a light form that is somewhat collimated. With the light rays coming from the grid being relatively parallel, they create a crisper LDE than the reflector or modifier without a grid.

Top left: A honeycomb grid is placed on a reflector to control the beam to make it come out in a series of narrower light parts. The spread of each tiny part of light is defined by the angle of and thickness of each small channel. Grids are designed for specific reflectors or light units.

Bottom left and right: Both images were made with a Profoto Magnum reflector. The image on the left was made without a grid, while the image on the right was lit with a grid. The difference between the lighting effects is most noticeable in the shadow created by the nose and the highlights on the brow. With the grid, the nose shadow is darker with a stronger LDE and the highlights are smaller.

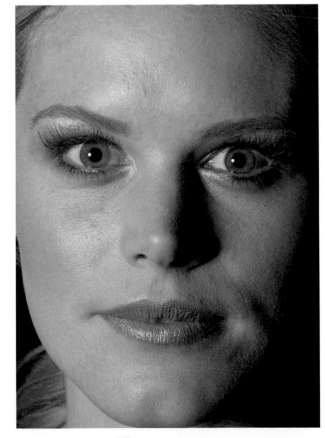

An egg crate is a modifier that is attached to the light surface of a softbox in order to channel its light. The device is made up of strips of black material arranged in a pattern of angled boxlike openings. The angle of beam control is determined by the size of the openings and thickness of the construction.

The Hardbox creates an enclosure for a light source with only a small controllable light exit. In this way, the unit creates a small crisp light beam with a hard LDE and shadow and highlight characteristics similar to daylight.

Egg crates and louvers are devices used to create more collimated light from a softbox. They give more directionality to the light without eliminating the inherent softness of the modified light. Both egg crates and louvers strengthen the LDE and have little if any effect on the highlights. As egg crates channel the light on both axes of the softbox, they will have a uniform effect on the LDE. Louvers are used either vertically or horizontally on a softbox and therefore will sharpen the LDE slightly perpendicular to the louver while having no effect in a parallel direction.

Tubes or light boxes also are channeling devices. These create a tunnel from the light source toward the subject being lit. They are normally designed to work with specific reflectors and are often augmented with grids to further collimate the light.

Egg crates and louvers are devices used to create more collimated light from a softbox.

LENS BEAM CONTROL

There are three primary functions for lenses as modifiers: to focus the light at a specific spot or distance, to defocus and spread the light, or to collimate the light.

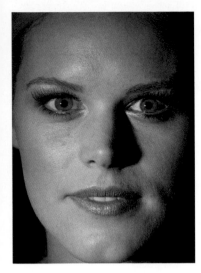

The Fresnel lens produces collimated light, creating a well-defined LDE and tight highlights. Because the beam is collimated, the light can be restricted to a specific area.

The Fresnel lens—a lens made up of concentric circles—is the most commonly used modifying lens in photography. It is designed to create a light beam with close to parallel, focused light rays. While a Fresnel lens can be "defocused" to create a wider light pattern, it is primarily used to create a light form that mimics sunlight. This creates a strong LDE and well-defined highlights.

When focusing the light at a specific spot is required, a spotlight modifier is a far better lens than a Fresnel. A spotlight lens arrangement includes one or more lenses designed to bend the light rays so that they cross at a specific point in space. Within this type of modifier unit either the lenses or the light source can be moved to change the point of focus for the light. At the point of focus, this light is as specular as any other light available. At or near focus, the LDE will be exceptionally well-defined and the highlights will be intense.

For some effects, photographers must defocus and spread the light, similar to a floodlight. This can be accomplished with lenses as part of a light unit or by attaching them to a reflector.

The Cine Reflector Basic Video Production Kit includes five lenses designed to fit in front of the light unit. These include a Fresnel, focusing spot, and three different flood lenses to vary the amount of spread of the light. Also shown in this kit is a diffusion filter.

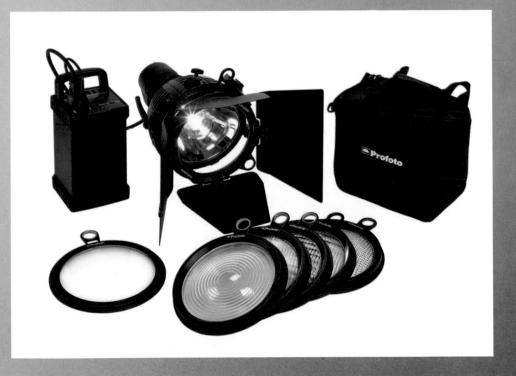

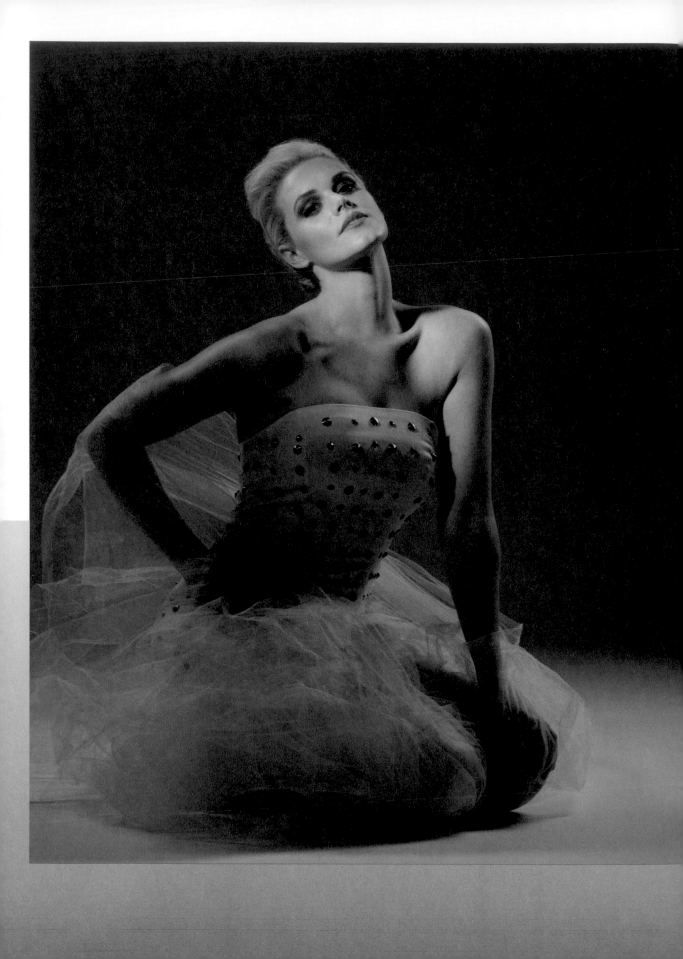

IN REVIEW

1. The most common way to modify or direct the light's beam is with a reflector. Reflectors vary from flat to a deep bowl shape. When the shape of the reflector is parabolic, the beam can produce a collimated light.

2. The surface type of the reflector affects the crispness of the light. Polished or lightly brushed surfaces produce more specular light than white or pebbled surfaces. How the light source is placed in relation to the shape of the reflector affects the beam's structure, particularly with spherical, parabolic, or deep reflectors.

3. Beyond reflectors, there are two main methods for controlling the light's natural tendency to radiate and spread. These are channeling (such as using a grid) and refracting the light with lenses.

Facing page: This image by Tim Meyer gains its strength from the specular light coming from a Fresnel spotlight. The crisp collimated light produces strong shadows and specular highlights.

Right: To start, a 9-foot medium-gray seamless backdrop was pulled out to provide ample space behind the model to allow falloff for the tone in the background. The main light was a Fresnel spotlight that was aimed down, creating a light pattern illuminating the head and upper torso. On both sides of the set and behind the subject, 1x6-foot softboxes were used with 45-degree inclinations to the rear. Both softboxes were aimed so that their light patterns created fill light on the subject without illuminating the background. Light from the softboxes not only provided fill and accents for the arms but also created a white-lining effect for the sheer wrap material. The narrow-beamed nature of the Fresnel lens allows only select areas of the model to be highlighted.

6

SPECULAR MODIFIERS

As discussed earlier, specularity of light deals with how tight and close to parallel the light rays are when they illuminate a subject. The most specular light, therefore, would have no crossing light rays, such as a point source, bare bulb, laser pointer, collimated light, etc.

> *Specularity of light deals with how tight and close to parallel the light rays are . . .*

To create this image, Glenn Rand used two specular lights for the main area of the picture. Both were small spotlights focused tightly on the area of the pens. Because the pens had a brushed-metallic surface, the lighting spreads out across their shafts. At the same time, the chrome ends of the pens spread the specular light along the curvature. There was enough ambient scatter of light not to require any additional fill.

Right: To accent this model's face, Tim Meyer chose a specular light. He used various diffused lights to shape the other parts of the model. This type of lighting depends on highlights rather than shadows to define shape and volume. To achieve the desired effect, we must rely on the specular quality of the light. While Tim used several diffused light sources in this setup, it is the main light—the spotlight—that provided the desired look. **Above:** A Fresnel spotlight was used to sculpt and brightly illuminate the face to create a sense of separation from the rest of the image. Meyer turned the model toward the Fresnel, thus avoiding heavy shadowing on the face. The fill light was provided by an octabank. Since the octabank was aimed down, the texture and color of the material of the skirt became problematic. To give enough light to show the material of the skirt, a silver reflector was placed on the floor in front of the model. The reflector opened up the detail in the skirt. Two 1x6-foot softboxes were used from both sides to edge light the model's arms and provide illumination for a slight rim light on her hair.

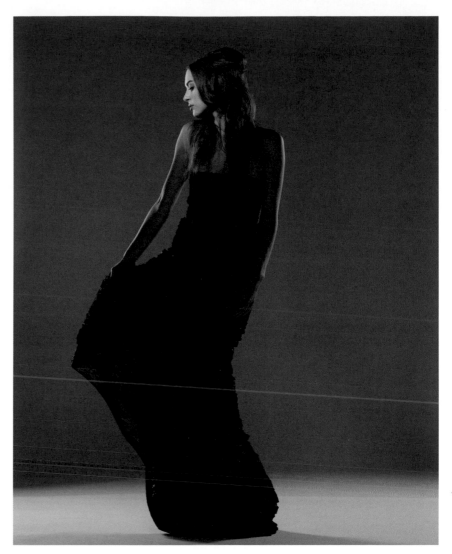

It is important to note that, with the exception of very few conditions, there will always be a specular component in the light. This specular complement sets the direction of the light visible on the subject. It is the portion of the light responsible for the shape of shadows. As long as there is a specular component to the light, there will be directional shadows.

Distance also has a major effect on all light. As a lighting unit is moved farther away from the subject, two things happen. First, the intensity of the light is reduced in relation to the Law of the Inverse Square. As discussed earlier in the book, moving a light away from the subject can be a major tuning device for the intensity of the light. However, in this discussion, the effect of moving any light away from the subject makes the light more specular. As discussed

earlier, the farther the light is from the subject, regardless of its size, the fewer angular light rays will reach the subject. Thus, there will be a more specular look to the light.

To create a specular look with studio lighting, usually the light source unit is the controlling factor rather than an additional modifier. This is normally done with the use of specific reflectors, lenses, or the design of the unit itself. These units can be as simple as a singular point light source, such as a bare bulb, to complicated focusing units utilizing mirrors and lenses.

BARE BULB

The simplest specular light source is known as a bare bulb. Quite simply, this is a bulb that provides 360-degree light from a single filament or flash tube. This can be created with only a single socket and a clear-glass bulb. This light is the most specular light used in the studio. However, it is not commonly used for a main light. It finds its primary use as a fill source. Flat reflectors are often used with bare bulb units to restrict the light propagation to only 180 degrees. Any contouring of the reflector—whether with folding or forming into conical, spherical, or parabolic shapes—creates a floodlight effect.

With a bare bulb, the shadows created will have very hard LDEs, and there will be sharp highlights. While the highlights do not commonly create problems within lighting design, you should note that, if the illuminating power of the bare bulb (when used as a fill light) is close to that of the main light as measured at the subject, a double shadow will likely be created.

With a bare bulb, the shadows created will have very hard LDEs and there will be sharp highlights.

Left: To create an even bare-bulb look, a globe is placed over the light source.
Right: With a bare bulb, highlights will be small, the LDE sharp, and shadows dark if the subject is unaffected by other lighting.

While on a cover assignment in Japan, Glenn Rand was asked to photograph pottery at the museum of the national university. The university assured Glenn that they possessed all the lighting equipment that would be required, but upon his arrival, he found there were no bulbs to fit that equipment. Therefore, this image was made using a standard exterior floodlamp used to illuminate the building. Fill was added with mat board.

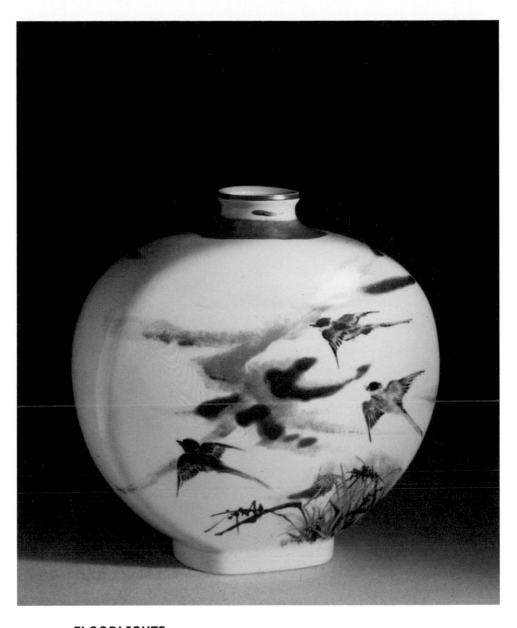

The floodlight is one of the most common light sources because of its simple construction.

FLOODLIGHTS

While floodlights are designed to fill areas with illumination because the light source is open to the subject with either a reflector and/ or lens used to spread the beam evenly across the area, the light unit acts as a specular source. Spreading the light in this way means that the light rays radiate in a controlled beam. This propagation of the light has very few crossing light rays and thus, when the light reaches the subject, it is mostly specular.

The floodlight is one of the most common light sources because of its simple construction. With a source mounted in front of

a reflector that has been formed into a shallow shape, the light will spread out in a wide beam. Because the light source itself is open to the subject it will have a strong specular component, even when a reflector is used that will spread the beam. At almost any distance, the highlights and shadows will be strongly specular. The LDE will be crisp with a small amount of softening created by the size of the reflector or lens.

Very common with today's floodlight constructions is the capability of building the flood's covering area by moving the light source in relationship to the reflector. As discussed in the previous chapter, this changes the angle of coverage of the floodlight. Some lighting units are designed with moving light sources, while others utilize repositioning of the reflector to change the flood pattern.

SPOTLIGHTS

There are basically two types of spotlights: those that produce focused light and those that create collimated light. While floodlight construction is simple, spotlight construction is complicated. In order for the spotlight to perform correctly, specifically designed mirror-and-lens combinations are used.

In most spotlights, a lens controls the beam, with the light source being projected into the lens from a reflector. This basic design either directs the light source into the reflector or uses a back-reflecting unit to direct the light toward the reflector, which then produces a constrained beam of light that is further modified by the lens. To produce a focused light, a meniscus lens (one that is wider in the middle than on the edges) is used. For collimated light, a Fresnel lens is used. In both cases, either the lens or lens systems' relationship to the light source can be modified to alter the beam. This change in distance can be accomplished by moving either the light source or the lens system.

The need to produce a constrained light beam from the reflector requires the lighting unit to be enclosed with only one area through which the light can exit—the lens. Therefore, light control housings are required for spotlights to operate correctly. Particularly with hot light sources such as modeling lights or tungsten sources, the construction of the housing for the source needs to consider heat dissipation. This can often require airflow designs that utilize fins and baffles or forced air.

For this image, Brenden Butler used a series of five Fresnel spots. The largest of these lights was 6 inches in diameter and was aimed up at the subject. The other lights, 4¹⁄₂-inch Fresnels, were used for fill, the hair light, and to light the background.

Focusing spotlights are designed to project a pattern of light with crisp characteristics at a specific distance. The light from a spotlight that is focused on the subject will create strong LDEs and sharp specular highlights. While not as crisp as a focused spotlight, a Fresnel spotlight creates strong LDEs and specular highlights. While it appears that the Fresnel spotlight is focused, its primary concern is to create a column of light. Both types of spotlights have dramatic falloff from their beams to non-illuminated areas.

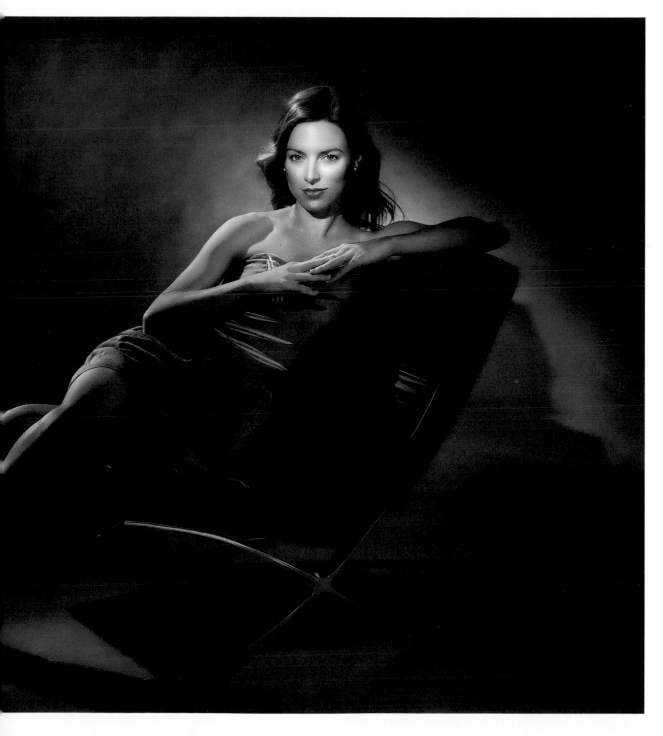

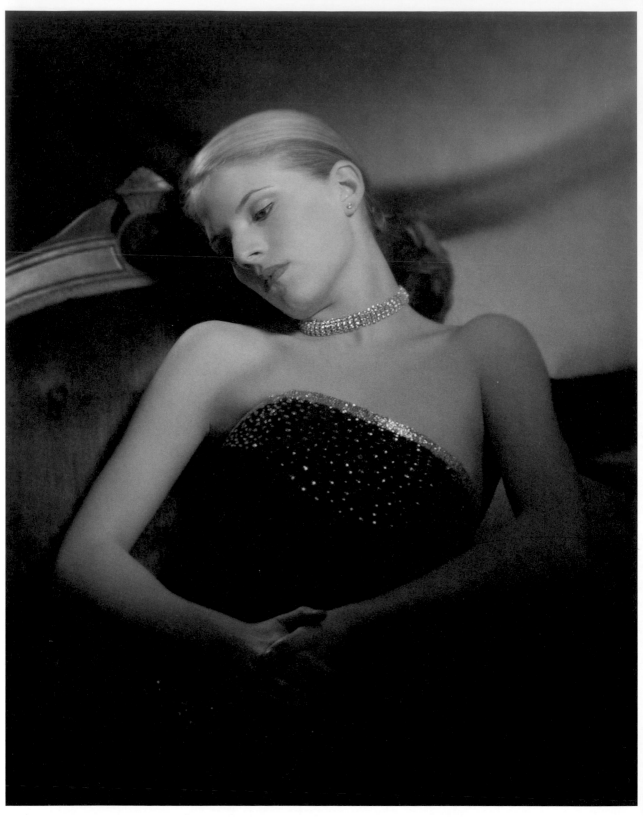

To emulate the 1940s Hollywood photographic style, Tim Meyer used a Fresnel spotlight to illuminate the subject. Two gridded reflectors were used to create the background light and the hair light.

Right: Drama is created by using a single specular light. Tim Meyer used a focused light to create the high contrast and the dramatic falloff. To help create the image dynamics, the model was placed close to the vertical portion of the seamless backdrop, allowing the shadow to be seen in the image. The harsh specular light created dark shadows, which can be distracting. For this reason, the model was posed on axis with the light and without large gaps that would allow shadow formation.

Above: A single Fresnel spotlight was focused to create a tight beam only illuminating the face and shoulders. Because the model was close to the background, her shadow and the spill light from the Fresnel spotlight could be used in the image.

IN REVIEW

1. As any light source is moved farther from the subject, its light will become more specular.
2. A bare bulb is the simplest specular light source. It is normally a single light source with a simple reflector or a light source emanating from a globe.
3. Floodlights are commonly open bulbs with simple reflectors producing a light beam with strong specular components.
4. There are two main types of spotlights. Fresnel spots produce collimated beams, while focusing spots are designed to create a light beam that is focused at a particular distance from the light unit.

7

DIFFUSE MODIFIERS

For many, diffuse light modifiers are what light shaping is about. As explained before, diffuse light is created when the light source is made up of many different angular light rays reaching the subject. The more angular difference in the light rays reaching the subject, the more diffuse the light.

Diffuse light is primarily created by large light-emitting surfaces. However, distance also plays a role in establishing the quality of the light. A large light-emitting surface positioned a great distance from the subject will have a strong specular feel. It should also be noted that many of the light sources just discussed as specular will have some diffuse complements depending upon how close

Left: This classical lighting approach uses a large light source to create a closed-loop/Rembrandt lighting pattern. The strong lighting direction emphasizes the structure of the face and the roundness of the eyes. *Photograph by Tim Meyer.*
Below: The main light, a 4x6-foot softbox, was used to create closed-loop lighting on the face. To maintain the proper lighting ratio while providing fill, a silver reflector was used. Two 1x6-foot softboxes were used on either side and behind the model. Using a 5-degree grid on a monoblock, directed to create a high-intensity light pattern on the background (which was also lit by main light), created the halo.

To create the soft "split lighting" look, Tim Meyer used a strip softbox from the right and had the subject rotate her head until the split on the face was accomplished. Using gridded small reflectors created the highlight on the hair and left side of the subject.

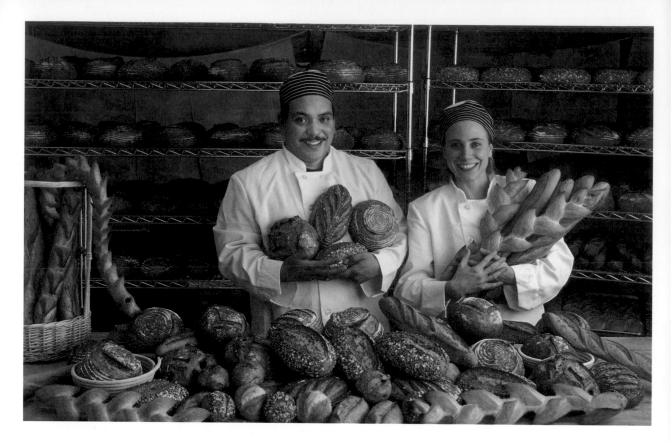

they are to the subject and the atmospheric conditions around the subject.

While this image looks as though it was made with window light, a flash was used to illuminate a bed sheet suspended on the right side of the area. *Photograph by Randy Duchaine.*

DIFFUSER PANELS

Perhaps the easiest way to consider creating diffuse light with all sources is by spreading a translucent material between the light source and the subject. The denser the material (while still remaining translucent), the more diffuse the light will become. This is because the light will be scattered more efficiently with a higher density of the translucent material.

Common materials that are used to create diffuser panels include but are not limited to cotton cloth, ripstop nylon, frosted mylar, and heat-resistant mesh sheets. While these materials are quite commonly used, any translucent material will do—even a white bed sheet. (The denser the bed sheet, coarser the threads, or tighter the weave, the more diffuse the light will be and the less specular complement the final light will have.)

It is important to note that when a specular light, speedlight, spotlight, or floodlight is aimed directly at the subject through a

The denser the material (while still remaining translucent), the more diffuse the light will become.

diffuser panel, the overall sense of the light will be soft, but there will be a specular component in the light that creates more distinct shadows, LDEs, and specular highlights.

Another issue with the creation of diffuse light using a diffuser panel is the angular interaction of the light with the diffusing panel/material. There are two factors that create more or less specular components within this formation of diffuse light. First is the size of the light projected on the diffuser panel. With all other factors held constant, if the pattern of light covers a large portion of the panel, then the light will be more diffuse. The second control factor is the angle at which the light strikes the panel. As suggested above, if the light is directed perpendicular to the panel, then the light will have a greater specular component. If a very diffuse light is desired, the light unit illuminating the panel should be aimed so that it would not shine directly on the subject if the panel were removed.

When shopping for a pre-made diffuser panel, you will often find aluminum or plastic tubular systems with removable diffuser panels. Many photographers use collapsible frame diffusers. These frames are commonly a circle and collapse for storage or taking on location. These are lightweight and can be mounted to stands or easily handled by an assistant.

A large home-made diffuser such as a bed sheet can be stretched out between the light source and the subject, but a structure is often required to hold the diffusing material in place. This can be done with light stands, ropes, wires, or rigid frames. Rigid frames provide flexibility in how the diffusing material can be used and therefore the relationship of the diffuse light to the subject. These frames are often constructed of lightweight material such as plastic tubing that can be folded or disassembled to make them more portable.

TENTS

Using a tent is the ultimate way to add diffusion material between the light source(s) and the subject. A tent is a structure, often supported by a frame, that completely surrounds the subject in translucent material. Tents can be purchased but are also easily constructed to meet the specific needs of a particular photographic setup. Tents are specifically helpful when photographing highly

These frames are often constructed of lightweight material such as plastic tubing . . .

The Profoto Still Light XL is a rigid light box designed to produce an even diffused light across its face.

This image was made with one floodlight passing through a diffuser panel. Because the light was aimed directly through the panel at the subject, it retained specular components, producing weak but obvious shadows. *Photograph by Glenn Rand.*

reflective subjects, as extraneous reflections from set elements can be eliminated. However, it should be noted that when photographing highly reflective subjects such as polished metal in a tent, every plane change of the tent will be reflected in the subject's shiny surface.

Perhaps the most elegant small tent is a white translucent globe used to cover outdoor lighting. These globes have a circular opening through which the camera can see into the light environment. Because the inner surface of this structure is a sphere, light sources showing on the outside will fall off naturally. Without any rigid structure or connected surfaces, there will be few if any discontinuous and unintentional light forms reflected in the subject.

> *Perhaps the most elegant small tent is a white translucent globe used to cover outdoor lighting.*

Above: In this setup, an octabank softbox served as the main light for the face. The unit was used in a near Paramount position, from above and to the left. However, this would leave the wardrobe without significant tones needed to define the textures of the materials and their forms. To solve the black wardrobe problem, several modifiers were used to add specific angles of light onto the model. First, a 4x6-foot softbox was used from the right side near the floor. This created a diffuse light that could reflect from the specular surfaces of the boots and skirt. This also provided fill for the entire image. Further, light was added for the lower part of the image with a silver reflector placed on the floor in front of the model. Two 1x6-foot softboxes were then placed behind the model on either side to create more reflections from the skirt material. Last, a monoblock was used to illuminate the background.

Right: The subject often dictates what type of light and how much illumination is needed to capture an image. Here, Tim Meyer needed to use a large amount of light from many directions to define the various black forms that made up the model's dark wardrobe.

SOFTBOXES

A softbox is a modifier consisting of diffusion material typically supported by an external frame constructed of lightweight rods. The fabric structure is mounted to the light source with rods connected at a speed ring, creating a rigid base. This makes an enclosed unit that has light-reflecting material on the inside and normally black material facing out from the unit. The large reflector system directs the light away from the source and the reflective material maximizes the light output from the unit. Opposite from the light source in the structure is a translucent material that will scatter the light, creating a diffuse source on the surface of the softbox.

To decrease the specular component that is created by the light source shining directly through the translucent front of the softbox, a light baffle or internal diffusing panel is used to scatter the light prior to its reaching the translucent opening in the softbox.

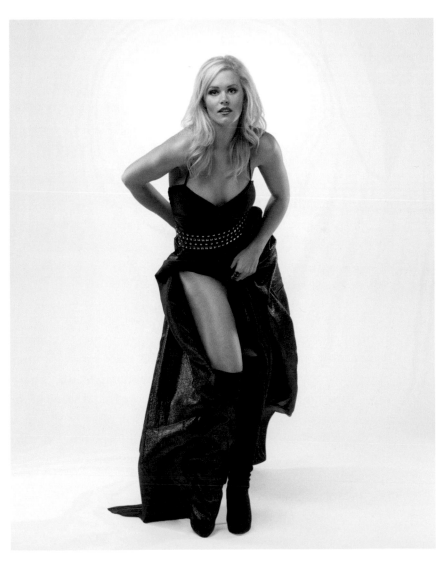

Profoto 4x6-foot softbox.

The Profoto 5-foot Octa.

In the top image, the model was lit with a 4x6-foot Profoto softbox. In the bottom image, the model was lit by a Profoto Octa softbox. The surface area of the two modifiers is approximately the same, the only difference is the shape. Looking at the two portraits, there are small differences in the LDE and highlights, with the Octa softbox being smoother and more uniform. The real clue to the difference in the lighting approach is the shape of the catchlight.

This tent-like structure attached to a light source can be created in many shapes, but the rectangular variety is most common. Rectangular units can be produced in any size; some are quite large, while others are small enough to be mounted on the camera. Particularly for portrait photographers, a more round shape of the light is desired. This is because the softbox will often be shown as specular reflections in the eyes, and a portraitist prefers a circular reflection in the eyes to a rectangular reflection. Two methods

Particularly for portrait photographers, a more round shape of the light is desired.

are used to create this circular light source. First, a mask can be placed over a rectangular softbox to restrict the light surface being used from the softbox to a circle. Second, a softbox structure in an octagonal shape (called an octabank) can be used. This type of modifier is near circular in shape.

Beyond the dissimilar shapes of the specular reflection in the eyes of the subject, the difference in a rectangular shape softbox or an octagonal or round softbox can be seen in the shadow generation. The shadows will be softer when perpendicular to the long direction of the softbox. With an octagonal or round light surface there is no variation in shadow softness or LDE.

Even within the rectangular shape there are great differences in the illuminated surface shapes. Primarily these are narrower forms of rectangles, sometimes referred to as *strip lights*. However, we will also find the term *strip light* used to define specially designed light sources. A strip light type softbox will create a complex

> **The shadows will be softer when perpendicular to the long direction of the softbox.**

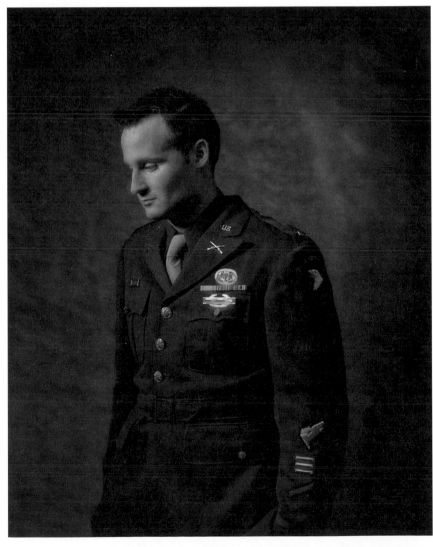

Above: The 1x6-foot Profoto softbox is particularly effective as an accent light.

Right: While not commonly used as a single source main light, here a strip light, a 1x6-foot softbox, was used. The orientation was horizontal, with the softbox tilted up and away from the subject to create falloff below the waist.

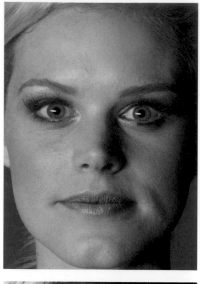

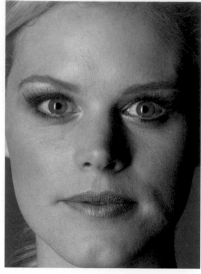

The two images show the use of a 1x6-foot softbox. For the image on the left, the softbox was positioned horizontally, while the softbox was in a vertical position for the image on the right. The effective differences can be seen in both the LDEs and highlights. The LDE is more distinct and somewhat specular perpendicular to the softbox; therefore, the shadow from the bridge of the nose is more prominent in the vertical orientation. Also, with the horizontal orientation, the highlights are smoother because they are diffused across the face.

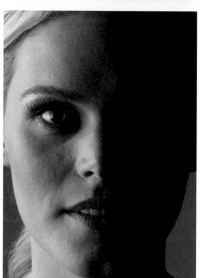

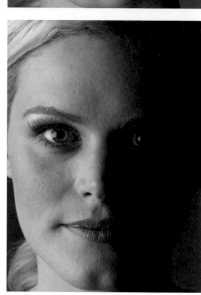

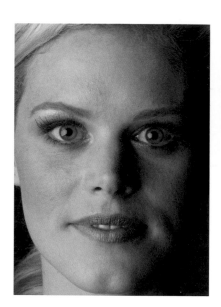

"Walking the box" means changing the relative location of a softbox perpendicular to the camera axis. In this comparison, we start with the front edge of the softbox aligned with the model. In this position, a near split lighting is created with the light more specular on the front of the model's face and more diffuse toward the rear. As the softbox is moved toward the front and with the model aligned with the middle, the light becomes more diffuse. As the softbox moves to a position with the back edge aligned with the model, the light on the light side is totally diffuse. The shadow side of the model's face shows moderately diffuse light with dark shadows and smooth LDEs.

shadow. The LDE parallel to the long direction of the strip light will be diffuse, while the LDE parallel to the short direction will be more specular. Therefore, with the strip light, both specular and diffuse shadows are created within the subject. This provides the photographer the potential to accent certain portions or features of the subject while at the same time softening other portions.

While softboxes are more common, rigid light boxes are used in the same manner. Their rigid construction allows for these light boxes to be developed to provide extremely uniform light across the entire diffuser surface. They also have the advantage of being quite flexible in terms of the internal lighting source. Some are constructed to be used with electronic flash, while others are used with continuous sources. The rigid construction also means they can be constructed quite large or used as building blocks to create a large light surface.

A special type of a rigid light box is a hazy light. The hazy light utilizes a purely parabolic rigid reflector with a light source positioned at the focal point of the parabola. This generates parallel light rays that are then reflected through a diffusing panel. The hazy light produces an unusual light similar to that coming from a bright sky through a haze.

A 4x6-foot softbox was positioned horizontally on the left at 90 degrees to the axis of the camera with a strip softbox in the vertical position on the right to produce the right-side edge light. *Photograph by Tim Meyer.*

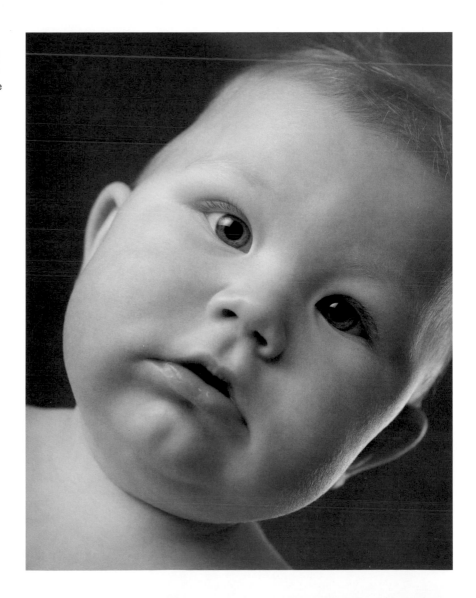

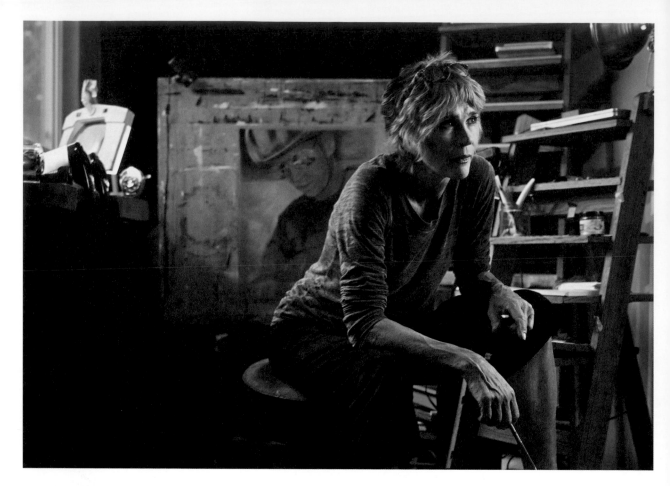

BANKS

When a broad field of light is required, light banks are often used. These modifiers normally include numerous flood-type lights, which overlap each other's pattern to create an expanse of diffuse light. The introduction of new solid-state electronic lighting sources—primarily, the use of an array of light-emitting diodes (LED) and electroluminescent lighting (EL)—has allowed the creation of various sizes and shapes of lights that can be used as a diffuse source shining on the subject or a light source within the subject. With some LEDs, the color of the light can be varied. Such lights may be tuned to give a precise color rendition to the subject.

REFLECTOR BOARDS AND KITES

We started this chapter discussing a simple method of passing light through a translucent material to create a diffuse light pattern. In a similar way, we will end our discussion of diffuse light shaping with

In this image, the light from the window on the left was balanced with a large softbox from the right. The broad and relatively stronger light from the softbox produced split lighting on the subject. The softbox was aimed so that there was little light spill into the background, allowing the brightness of the face to separate from the background. *Photograph by Nick Korompilas.*

a look at reflected diffusion techniques. These are low-tech, low equipment specific solutions to creating diffuse light. Here, we are talking about creating major diffuse light environments using reflection as a primary light modifier. In chapter 10, we will take a closer look at using passive modifiers, reflectors, flags, and gobos.

Because so much of the motorcycle is made up of specular surfaces, very little direct light was used to illuminate the subject. A softbox was used to add light directly on the front of the subject. Several large white boards were illuminated with lighting that was blocked from directly shining on the motorcycle and used to surround the motorcycle with diffused light. In all, twelve surfaces were used to light the subject. *Photograph by Glenn Rand.*

The simplest way to use this light modifying technique to create diffused light is to reflect the light source into a board with a white or metallic surface. If the surface is diffuse in nature (i.e., not shiny but with a light or substantial texture), then the light reflecting from the board will be diffuse. The advantage of using a flat board is that when the light beam strikes the board's surface, it will act as though it is being reflected by a mirror, so the light can be aimed at the subject. Because the surface is diffuse, the light will be diffused as it reflects toward the subject and the effective size of the reflected light source will be the lit size of the board in relation to the subject.

Perhaps the simplest material to use in this manner is foam core board. This board is rigid and lightweight and can be held in place with clamps and light stands. Seamless paper can be used to create a very large reflector, and boards covered with small pieces of aluminum foil, shiny side out, can be effective, too.

In many situations, a large diffuse light with a downward direction is desired. This is often accomplished by the use of overhead reflectors made of cloth or other lightweight, flexible materials. These are often referred to as *kites*. The material is suspended by lines attached to rigid points on the ceiling, walls, or nearby structures. The stretched material creates a near-flat reflective surface that the light sources can be aimed at to create diffuse light on the subject. This approach is not new; in fact, Renaissance painters were known to use the device to create the desired light on subjects sitting for portraits.

This board is rigid and lightweight and can be held in place with clamps and light stands.

IN REVIEW

1. The primary method of modifying light for a more diffuse quality is to enlarge the light's surface.
2. Panels are the simplest modifier used to produce diffuse light. Panels can be purchased or easily constructed–even a bed sheet can serve to diffuse light.
3. Tents are translucent structures that are lit from the outside with the subject inside. They are commonly used to photograph highly reflective subjects.
4. One of the most commonly used modifiers is the softbox. They are usually constructed with large reflecting surfaces and a diffusion panel and come in many shapes and sizes.
5. Other common pieces of lighting equipment that produce diffuse light are banks of lights, reflector boards, and kites.

8 UMBRELLAS

One of the most used modifiers is the umbrella. We are taking up a chapter to discuss umbrellas because they do not fit neatly within either a diffuse or specular concept of lighting. While some umbrella designs have specific specular/diffuse characteristics, many umbrellas can be used to produce various light qualities.

Umbrellas, as the name implies, are fabric forms held out by lightweight arms.

Being in the great outdoors does not mean that light shaping is not needed. For this image, an umbrella was used with a speedlight to create the desired lighting on the subjects. It was important to ensure that the angle of the umbrella's beam would be consistent with the sunlight illuminating the background. *Photograph by Tim Meyer.*

This location image was made possible by umbrellas. The big space needed a large amount of light to be controlled to allow balancing with the exterior light. To do this, four white umbrellas were used to provide ample diffused background lighting with enough control to illuminate the face and create the falloff of light into the background. Because umbrellas are lightweight and collapsible, they can be easily used on location. *Photograph by Glenn Rand.*

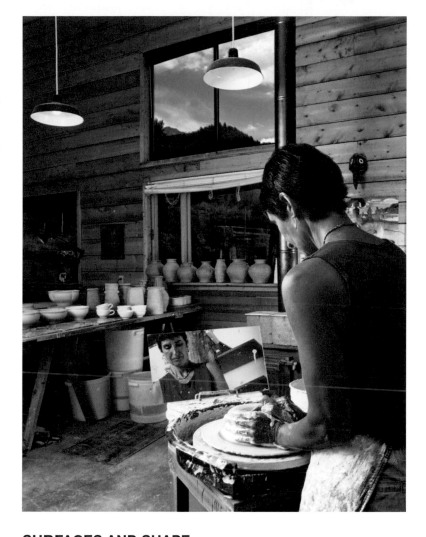

SURFACES AND SHAPE

Umbrellas, as the name implies, are fabric forms held out by lightweight arms. Depending on the design requirements of the internal surface of the umbrella, eight to twenty or more arms will be used to shape the form. Though the arms hold the shape of the umbrella, the material supported by the arms actually determines the shape. The arms are tension elements to stretch the fabric to its designed shape. The pressure elements spread the arms and, along with the fabric, deform the arms to create the needed form for the umbrella.

> *Though the arms hold the shape of the umbrella, the material actually determines the shape.*

Umbrellas feature a center rod. Many light sources are designed to clamp onto the umbrella's center rod or are built with a channel that allows the umbrella's rod to pass through the housing of the light source. For light sources that are not designed for umbrella

use, clamps and mounting devices can provide a point to attach the rod to the light stand.

Like the umbrella used to protect oneself from the rain, a photographic umbrella collapses and is quite lightweight and portable, making it exceptionally useful for both studio and location applications.

Two types of umbrellas are used in photography: translucent ("shoot through") and reflective umbrellas.

The two common types of umbrellas are reflective and translucent. From left to right are shown: a reflective umbrella with white interior, a reflective umbrella with silver interior, and a translucent umbrella.

On the left is an image made with a reflective umbrella. The image on the right was made with a translucent (shoot-through) umbrella. The translucent umbrella produces darker shadows, more compact highlights, and a crisper LDE.

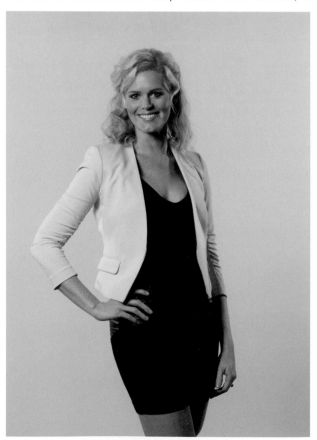
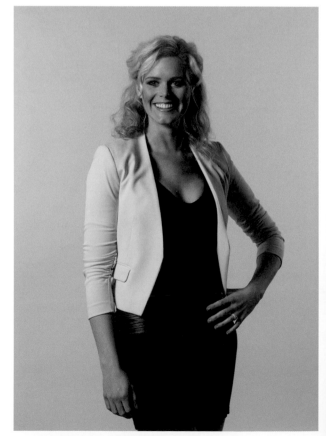

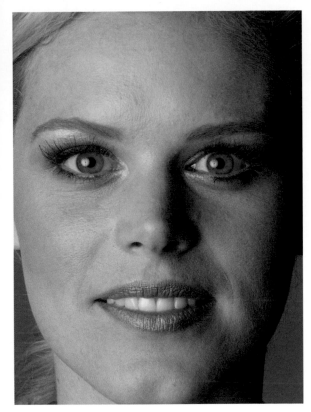 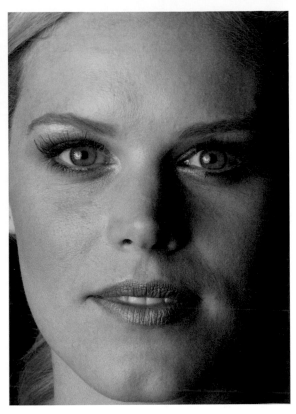

These two images were made with 7-foot umbrellas. The left photo was lit with an umbrella with a white surface, and the right image was lit using a silver umbrella. The white umbrella produced more diffuse light with a soft LDE and broad, smooth highlights. The silver umbrella created a more specular light with darker shadows, a sharper LDE, and crisper highlights.

The smaller the lighted area that is projected on the translucent surface, the more specular the light.

Translucent umbrellas are used much like a softbox or diffusion panel. The light source is mounted to the umbrella with the source pointed at the target area through the umbrella material. Depending upon how far the umbrella is from the light source itself, a variable size of light will be created on the umbrella. The smaller the lighted area that is projected on the translucent surface, the more specular the light will be on the subject. It also must be noted that since the light is pointed at the target area or subject through the translucent material, even when the umbrella is close to the subject and fully lit to its maximum circle of light, it will have a strong specular complement.

More common are reflective umbrellas. These use a fabric construction that is similar to the outer surfaces of softboxes, with a reflective surface toward the light source and a black outer covering to restrict any light seepage through the umbrella. This type of umbrella usually has a white or metallic reflective surface.

These pictures show a standard 4-foot spherical umbrella (left) and a 7-foot parabolic umbrella (right). The light pattern on the wall shows the difference between the beam structures. While the parabolic umbrella is larger, because of its focusing design it creates a more defined beam than the smaller spherical design.

White umbrellas scatter the light more than metallic-surface umbrellas. This means that the light reflected by white umbrellas will be more diffuse than that reflected from metallic umbrellas.

The distance that the umbrella is from the subject determines the diffuseness of the light. Just like other diffuse modifiers, the closer the subject is to the umbrella, the softer the LDE and highlights will be. This is true of both white and metallic umbrellas, though white umbrellas are more diffuse than metallic at any particular distance.

The shape of the umbrella has a great deal to do with the strength of the beam it creates. The most defined beams are from parabolic umbrellas. These tend to be quite deep, therefore restricting the light beam to a fairly narrow and more specular light. The light beam from a parabolic umbrella will have a definite falloff pattern.

The Profoto XL is a deep parabolic form. Like most umbrellas, it is available in white, silver, and translucent varieties.

We are using the name "spherical umbrella" because it closely resembles the form created, but depending on the quality of the design of various umbrellas, the shape may vary, from a part of a sphere to a more conical construction. The deeper the umbrella, just as with any reflector, the more restricted the beam and more likely a sharp falloff. Regardless, with these structures, the beam scatters the light more and has a more gradual falloff than the light produced from a parabolic umbrella.

Because the light source is adjustable on umbrellas, the quality of light—its specularity, diffuseness, beam structure, and falloff— make umbrellas the most adjustable light modifiers commonly used in photography. With the light adjustment, the LDE can vary

from mostly specular for a parabolic metallic reflector with the light source at the focal point adjustment on the rod to reasonably diffuse with an open spherical white reflective surface and the light source completely illuminating the umbrella.

Further, with the differences in beam forms, rotating the angle of the umbrella to the target area can vary the quality and overall covering power of the light. Particularly with spherical umbrellas, there tends to be a central beam with falloff to a secondary beam. Depending upon the severity of the drop-off in intensity between the central beam and the outer light, there may develop a portion of the light that creates a complex light pattern on the subject. This would be created when the central beam primarily illuminates a portion of the subject and the secondary light intensity illuminates other portions. This can produce multiple LDE structures on the subject. Some photographers consider this a "sweet spot" in the light. To accomplish the use of this "sweet spot," the distance of the

> *With spherical umbrellas, there tends to be a central beam with falloff to a secondary beam.*

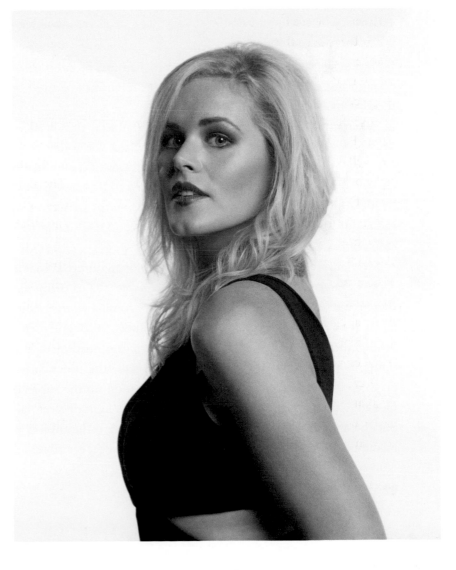

Above: Here, a large parabolic white umbrella served as the main light. The larger size and the parabolic shape of the umbrella provided a wide light with open shadows and created full, near-specular highlights. The background was illuminated with two white umbrellas to provide an even lightness behind the model. The bright background provided fill.
Right: This is a simple approach to providing a directional light source that has mostly diffused characteristics. Because no active fill is used, the broad lighting accentuates the facial structure. *Photograph by Tim Meyer.*

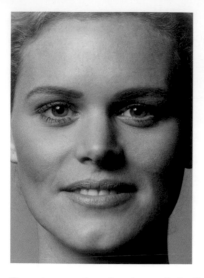 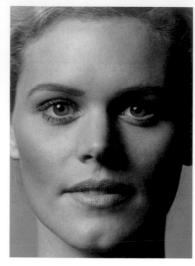 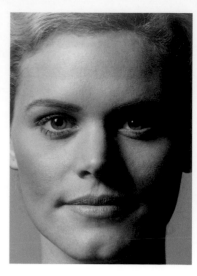

These images show the change in the lighting created by rotating an umbrella to change the shape of the light. The first image (left) shows the umbrella aimed at the model. In the traditional position, with this 4-foot white umbrella at 4 feet from the model, the light is diffuse and shows broad highlights and a soft LDE. When the umbrella is rotated 45 degrees , the loop on the model's left cheek starts to close as the overall light moves back and becomes narrower (center image). The LDE gets stronger and the highlight appears brighter and more confined. At the extreme of 90 degrees, the loop on the cheek is almost completely closed and the shadows are darkened with a strong LDE, particularly when perpendicular to the umbrella's rotation (right image). At this point, the highlights take on an angle parallel to the rotation of the umbrella.

subject from the nearest part of the umbrella must be substantial enough not to create an imbalance in light intensities because of the Law of the Inverse Square.

When an umbrella is rotated toward the subject, the shape of the light source, the circle of the umbrella, and the intensity of light arriving at the subject from various portions of the umbrella change.

If the umbrella is at a substantial distance from the subject, then the major change will be seen in the cross-axis LDEs, similar to a strip softbox.

More interesting is that with the rotation of an umbrella that is approximately the same distance from the subject as its diameter, there is a drastic change in the light intensity coming from various parts of the umbrella. When rotated to almost 90 degrees, not having the umbrella pointed at the subject, the portion of the umbrella that is closest to the subject will have the potential of producing more than twice as much illumination on the subject. Not only does the closeness of the edge create a light differential, but the ability of the surface to scatter light toward the subject is increased for the close edge while decreased from the far edge.

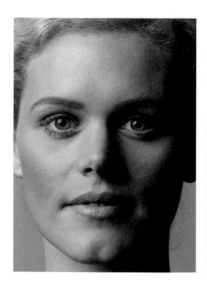

When a diffuser (a "sock") is placed over the front of the umbrella form, it breaks up the beam. This adds a diffuse portion to the light, softening the LDE and broadening the highlights. However, with silver and parabolic umbrellas, there is a strong specular portion.

Because of the falloff characteristics from umbrellas, it is possible to illuminate a large area perpendicular to the camera by rotating the umbrella and pointing the central axis at the point farthest from the umbrella, allowing the secondary beam to illuminate the area closest to the umbrella. This lighting concept is exceptionally useful when photographing moderately small groups, such as a wedding party.

GIANT REFLECTORS

A special class of umbrellas is the giant reflector. These are large-scale umbrella type constructions. Most giant reflectors use a parabolic structure to provide a large light beam of mostly parallel light rays. With the giant reflector at a comfortable distance, the light will have relatively distant-looking highlights while maintaining a moderate LDE and good directionality. Like any

Most giant reflectors use a parabolic structure to provide a large light beam . . .

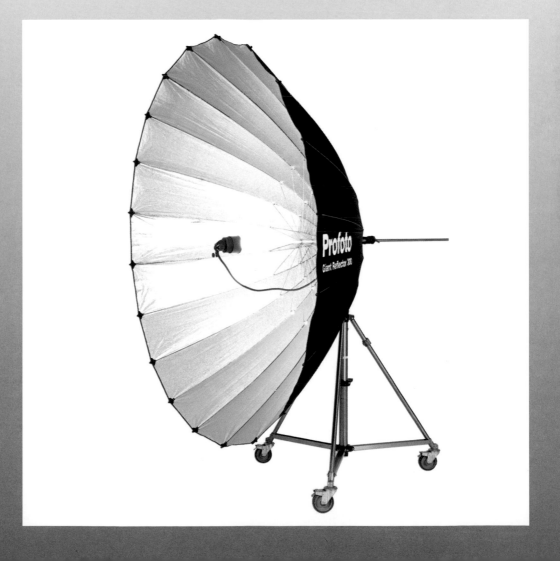

The Profoto Giant Reflectors range in size from 150cm to 300cm with both white and silver surfaces. Because the shape of the umbrella structure is parabolic or close to parabolic, the beam structure of the silver reflectors are mostly collimated, while white reflectors produce a more diffuse light.

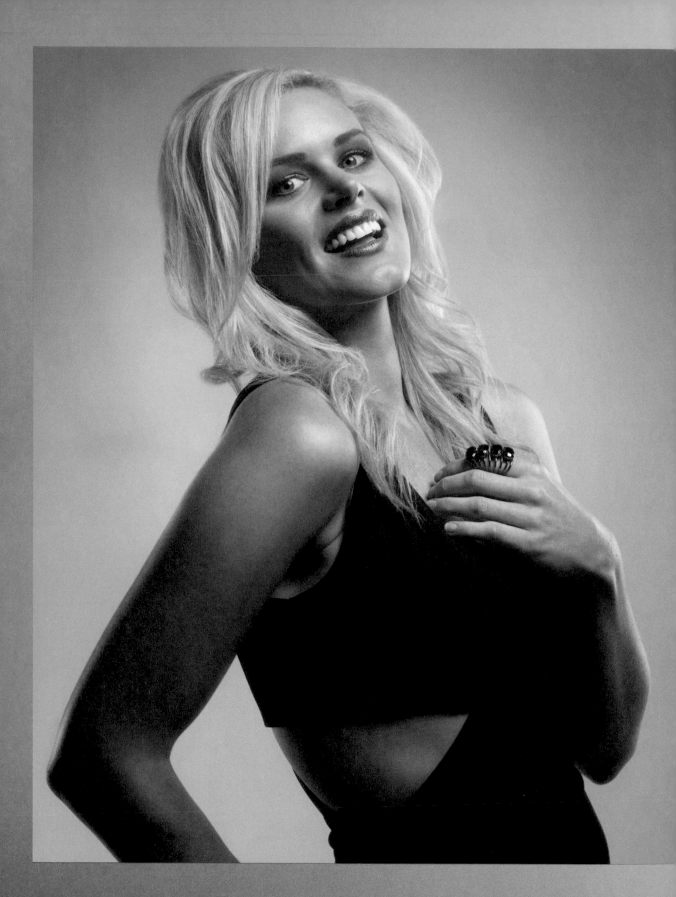

other light modifier, light from the giant reflector will become more diffuse as it is moved closer to the subject. When the subject is close to the reflector, the light tends to wrap around the subject. Using a close giant reflector with the subject entirely within the beam of the reflector is a very popular approach for fashion and glamour photography.

IN REVIEW

1. Umbrellas are among the most common pieces of lighting equipment. Some umbrellas are designed as direct diffusion modifiers, with the light passing through the umbrella.
2. Depending on the shape and materials used to construct reflecting umbrellas and their positioning in relation to the subject, they can produce a continuum of light quality from diffuse to collimated with a strong specular component. Spherical umbrellas can be rotated in relation to the subject to create different light effects.

ing page: To sculpt the model's
ures, Tim Meyer used a broad
ctional source to create strong
dows and then accented the
re with light to create defining
lights on the arms.

ve: To accomplish this dramatic
ting, a 7-foot silver parabolic
rella was used relatively close to
subject. Because the umbrella
parabolic and silver, the light
collimated and created specular
dows. Compare that to the
dows in the photo of the same
ject on page 91, which was made
a similar-sized light source.
light specularity in the 7-foot
er parabolic umbrella seems less
cted by distance than with other
ts. The accents were formed by
1x6-foot softboxes that were
itioned behind the model on
er side and in a near vertical
ition. This provides the rim light
he arms and accents the hair.

9

SHAPE, INTENSITY, AND ACCENTS

SHAPERS AND MASKS

While this entire book is about shaping and modifying light, a particular group of light modifiers are known as shapers. These modifiers are used to change the overall pattern of the light at the source. This defines the perimeter shape of the light. This affects both the highlight areas created by the light as well as shadows cast on or behind the subject.

Primarily, shapers are attached to an existing lighting unit or modifier (such as a softbox) to create a light form that will either create wanted highlights or restrict the light from reaching specific areas of the photographic set. While several of these can be considered intensity modifiers, we have decided to discuss them in a separate chapter because of their primary use in changing the shape of the light.

Masks are manufactured in a few shapes. They are particularly used to change a softbox to a round or strip source, but this is not

This image was a time exposure using a 4x6-foot softbox from the right side to create the base exposure with a flashlight and laser pointer used for the secondary exposure, for which the model was asked to move. *Photograph by Tim Meyer.*

SOFTBOX MASKS

A softbox mask is an opaque device of a specified size and shape that is used to alter the shape of the light emitted by the softbox. A circle mask, for example, changes the light form of the softbox from rectangular to circular. The light from a softbox modified in this way will have a different form of LDE, equal in all directions, and create different looks for specular highlights and catchlights in highly reflective areas of the subject.

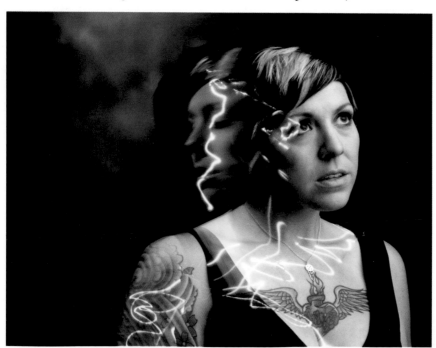

HIGHLY REFLECTIVE SUBJECTS

When photographing highly reflective subjects, the light source is often seen somewhere on the subject. Using a mask to modify the shape of a standard softbox can help to make the source less obvious to viewers.

Top: The concept for this image was to show the car as a series of defined highlights with texture added by water droplets. *Photograph by Al Redding.*

Bottom: To control the shape of the reflections on the surfaces of the black car, the large softbox was masked. Al Redding looked through the camera and directed the assistant to move the mask until it produced the desired reflection.

the totality of how the shape of a softbox may be modified. Some shapers are malleable, using Velcro or other fasteners to allow for the material to be modified into various shapes. On the other hand, it is quite simple to take opaque, normally black paper, and cut it to shape or piece it together over the light source to create the desired mask shape.

While creating or acquiring a mask for a softbox is one method of changing the shape of a diffuse light source, there are other approaches that are equally as effective and in some cases superior to the use of masks. This is particularly the case when using a suspended diffusing panel, butterfly, reflecting flat, or large kite. With these modifiers, light created on the diffusing or reflecting surface can be shaped by the use of a mask on a controlled-beam source or by simply using the Law of the Inverse Square and the falloff created by the beam to illuminate only a portion of the diffusing panel or reflecting surface.

This type of light modification is exceptionally useful when dealing with highly reflective surfaces. In these situations, because the illumination ends or falls off, the rigid edge of the illuminated

Facing page: The concept of this image was to highlight the texture on the piece of pottery while creating a background and set that would be indicative of the Japanese influences prominent in the piece of pottery. *Photograph by Glenn Rand.*

Above: A single Fresnel light was used for this image. A white reflector was positioned to the left of the pottery to add fill and a reflection on the vessel's left side. A cookie was used to create open shadows falling on the background.

surface does not take on the shape of the diffuser or reflecting surface. With tight control of the light intensities on various portions of the diffuser or reflector surfaces, smooth contours or falloff can be created so that rigid edges are not reflected in the subject.

PATTERN PROJECTIONS

For more specular forms of light, mask or pattern holders are attached to the front of the light to create a specific focused light pattern. Depending upon the type of beam created by the lighting equipment, the mask can create a very specific shape of light that can be added to an area of the subject to illuminate only a small portion of the overall picture or create a light pattern for a background. When there is a desire to make the projected pattern distinct, an adjustable lens is placed in front of the mask or cutout pattern to allow precise focusing of the light pattern on or in the set.

While light patterns can accurately be projected as stars, flags, etc., it is also possible to use a small mask in a projection apparatus to increase the illumination in just a small part of the image. This increases the brightness in an area, providing more exposure and thus more attention to be paid to the highlighted area of the image.

Larger masking concepts or projected light patterns for photographic imagery often involve a *cucoloris* (commonly called a cookie). The effectiveness of a cookie for a photographic image often relies on the crispness or softness of the shadow pattern created. This has to do with the type of light (specular/diffuse), the beam structure, or the focus of the light fixture creating the light pattern through the cookie. Regardless of the specular/diffuse character of the light, the closer the cookie is to the surface that will have the light pattern cast upon it, the crisper the highlights and shadows created by the cookie will be. This sharpness of LDE between the light and shadow portions also has to do with the specular/diffuse nature of the light creating the shadow and beam strength of the light creating the pattern. If the light beam is focused through the cookie, the light pattern and corresponding LDEs will be crisp. If the light passing through the cookie is diffuse, the LDEs will be soft.

SHAPE, INTENSITY, AND ACCENTS 99

Light pattern projection creates both highlights and shadows. Either or both of these may be important in the photograph.

BARNDOORS

As mentioned early in the book, light energy radiates out in all directions. Within a controlled lighting environment, we want to manage both the beam of the light and the areas that are required to be without light. The most common equipment used to reduce the spread of the light into areas that are to remain darker are *barndoors*. Barndoors are blades that are attached to the primary light source. They are made to work with most lighting equipment, including softboxes. Obviously, the larger the light source, the larger the barndoor system that will be needed to work effectively.

Barndoors are attached to the front of a light source to control the radiation of the light. Depending upon the kind of light equipment that barndoors will be attached to, a frame with two or four hinged blades or "doors" is attached. The hinged barndoors are often attached to a ring that allows them to be rotated in front of the light source. For rectangular lighting equipment such as softboxes, the barndoors typically consist of only two blades, one on either side of the equipment.

Because the blades of the barndoors are attached to the light fixture itself, their closeness creates a soft LDE. This is often called "feathering." With feathering, a series of strong directional lights such as Fresnels can be aligned with their feathered edges created by individual barndoors overlapping to create a large pool of directional light without the need for a very large piece of lighting equipment.

GELS

Gels get their names from the early days of photography when gelatin filters were used to create color changes. Today, these modifiers are normally made of acetate or a polyester material with varying densities of colorant. When placed in front of the light unit, they change the color of the light. Gels for speedlights are manufactured with adhesive to hold them in place.

Gels can be used to balance color temperature—for example, in a mixed lighting scenario, when two different light sources with unlike color temperatures are being used, gels can be applied to

This four-blade barndoor modifier is designed to fit on a reflector. Its ring structure allows the barndoors to be positioned or rotated as desired.

Barndoors are attached to the front of a light source to control the radiation of the light.

balance the color of the light. Gels can be added for creative color, as well. Also, some gels are designed to diminish the light's power without affecting the color. These are known as neutral density gels.

Regardless of whether gels are colored or of the neutral density variety, they may reduce the intensity of the light passing through them. Since metering for exposure is done at the subject, the gels should be in place before metering and exposure calculation.

Dyes are used to create color in or on a gel. Polycarbonate plastics and polyesters are used as the support material. As gels are used in close proximity to the light source, their heat resistance or the heat generated by the light source must be taken into consideration to ensure color stability and durability of the gels. Even when using electronic flash, it must be considered that a

> *Some gels are designed to diminish the light's power without affecting the color.*

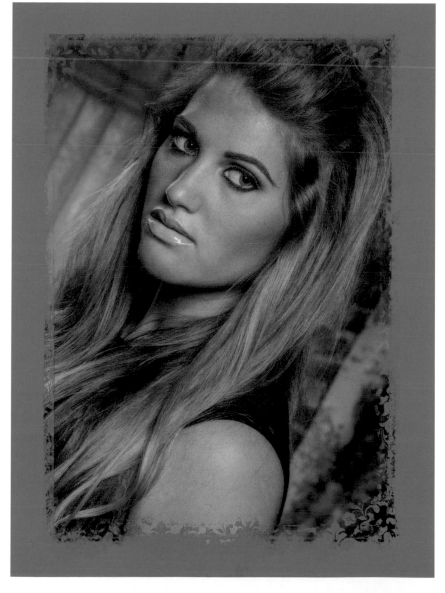

Above: This image was made on film. A #25 red filter was used on the camera, and a cyan gel (red's complementary color) was used to modify the light. The background shifted to red tones and the cyan gel neutralized the red on the model. *Photograph by Glenn Rand.*

Right: To create this intense color contrast, a gel was used to illuminate the background. The border color was chosen to match the reflected gel color. A beauty dish was used as a main light. *Photograph by Judy Host.*

modeling light is commonly a quartz halogen bulb that generates excessive heat. Therefore, when using gels, it is recommended that photographers choose heat-resistant varieties or use the modifiers in combination with a heat-shielding device to keep excessive heat from building up on the surface of the gel and destroying it.

SCRIMS, DOTS, AND FINGERS

Scrims, dots, and fingers are light-control devices used either between the light and the subject or, in the case of scrims, photographed through to change the light intensity seen in the final image.

While dots and fingers are often comprised of a solid material, scrims are constructed of either fabric or metal mesh. The mesh construction allows light, whether it is traveling to the subject or from the subject to the camera, to be reduced or modified. Metallic mesh is used when the screen material will be close to a light source that generates a great deal of heat. While metallic mesh scrims can be used close to a hot light source, fabric scrims must be used at a distance so that they do not ignite while in use.

Fabric scrims are also commonly used to modify backgrounds by placing them beyond the depth of field of the lens being used so that they reduce the intensity of a background coming toward the camera. Though scrims are often either black material or black painted, some scrims are a natural metal color or white material. White scrims are commonly used between the camera and subject to create a foggy, out-of-focus look. They can also be placed between the light and the subject to diffuse the light.

Dots and fingers are devices that are suspended between the light and the subject to create a small shadow or suppressed light intensity on the subject. Though dots are usually circular devices, there is no restriction to their shape. Thus an irregular-shaped dot can be constructed to form a specific shadow or lessening of intensity on the subject. A finger is a modifier with a longer, thinner shape that is suspended between the light and the subject to decrease intensity in a long, narrow area. Depending upon the size of the light being modified, a dot or finger can be constructed of solid material, gel, or scrim. Moving the dot or finger closer to or farther away from the light source will modify the size of the pattern of reduced intensity.

This image was lit with two highly snooted lights. The larger light was used to create the swirls on the left of the image. *Photograph by Glenn Rand.*

Though scrims are often either black material or black painted, some scrims are a metal color . . .

The main light for this magazine illustration was a large overhead softbox. Because the light was coming down at the set, the bonnets on the dolls cast shadows on their faces. To lessen the shadows, small masked mirrors were used to redirect light from the softbox onto just the faces. *Photograph by Glenn Rand.*

CONES AND SNOOTS

There are times when the shape of the light needs to be constricted without affecting the beam characteristics. To do this, the light is directed from the unit through a tunneling device called a cone or snoot. Unlike grids, these channeling devices only restrict the size of the light; they do not modify the beam structure.

While cones and snoots can be designed to fit any light unit, they are primarily used with smaller light sources. Cones and snoots are normally designed to hold gels, grids, etc.

MIRRORS

Another option for adding a small amount of light—or increasing the light intensity—at specific points of an image is to use a mirror to reflect light onto the subject. This is particularly useful with tabletop photography since the subject will be still and the additional light can be precisely added.

Mirrors of various sizes can be used, and a light unit need not be assigned for illuminating the mirror to achieve the desired effect in the image. Mirrors designed for auto mechanics and to put on makeup tend to be very useful since they often are supported with either a flexible material or multi-directional gimbal, which allows for accurate positioning. Also, tape or paper cutouts can be used over the mirror to change the size and shape of the reflected pattern of light that will be added to the subject.

The light that is reflected from a mirror onto the subject has the same characteristics as the light that illuminates the mirror surface.

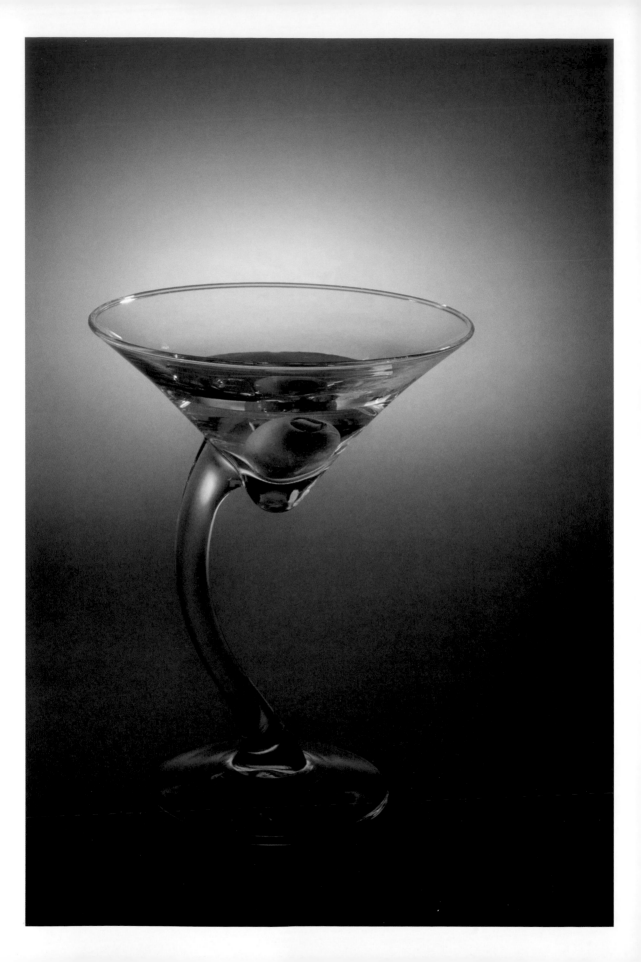

The Profoto strip lights are available in three lengths, allowing photographers to insert a narrow light form into the light environment.

Facing page: This image was made as part of a glass lighting workshop attended by students of the Professional Photography Program at Colorado Mountain College. A snooted light was directed at the background, and a small snooted accent light was aimed at a fill card to the left of the glass. To light the olive, a small mirror was used from above the glass to avoid any major speculars. *Photograph by Guadalupe Laiz, Cary Tozer, and Adam Hughes.*

If the subject is lit with a diffuse source and the mirror falls within that light's field, then the light reflecting from the mirror will also be diffuse, though it will come from a slightly different direction.

OTHER TOOLS FOR ADDING LIGHT INTENSITY

Several specifically designed light units can be added to a light environment to introduce the desired intensities into the image. A light stick or other small units can be inserted into or behind the subject for increased light intensity in even tight quarters. Today's light-emitting materials include panels, ribbons, and cords—all of which are available in adjustable intensities. *(Note:* Light sticks are available in flash and continuous light varieties, but light-emitting material is only available as a continuous light source.)

Flashlights can also be used to paint light onto a subject in select areas. They can also be used as small accent lights. Color balance for flashlights is important, particularly with tabletop photography. With the introduction of LED flashlights, a new color temperature mix has been added to existing incandescent lighting. White LEDs have a good color match when used as slight accents in electronic flash setups, while Maglites are well matched for tungsten lighting scenarios.

IN REVIEW

1. Masks or shapers can be affixed to the lit surface of a light unit, changing the shape of the light illuminating the subject.
2. Patterns can be projected to either restrict the area being lit or to create a specific shadow shape on the subject or background.
3. Barndoors are commonly used modifiers that control the spread of light.
4. Gels are used to change the color of a light source.
5. Scrims, dots, and fingers are used to reduce the light intensity in specific areas of the image.
6. Cones and snoots allow for narrowing the beam of a light unit without altering its overall characteristic.
7. Other tools such as mirrors, small LED lights, flashlights, etc., can be used to insert light into small specific areas of a subject.

FILLS, NON-FILLS, AND BLOCKING

The simplest light shaping is to control reflections on the subject. This can be done as either a positive reflection (adding reflected light) or a negative reflection (reducing reflected light). While this was mentioned briefly when discussing diffuse modifiers, in this chapter we will go into more detail about using passive modifiers, reflectors, flags, and gobos.

Another lightweight solution available to the photographer is the collapsible reflector.

FILL LIGHT

Regardless of whether fill light comes from the ambient light, light units, or a reflector, it opens shadows and softens the contrast within an image, lowering the lighting ratio. This can be thought

This image uses no direct light. Instead, a series of five small reflectors were used to create the light effects seen in the image. Each small reflector had a light directed at the reflector in a way that did not shine any direct light on the fork. *Photograph by Glenn Rand.*

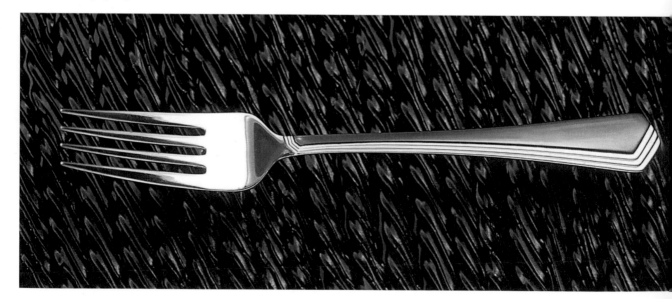

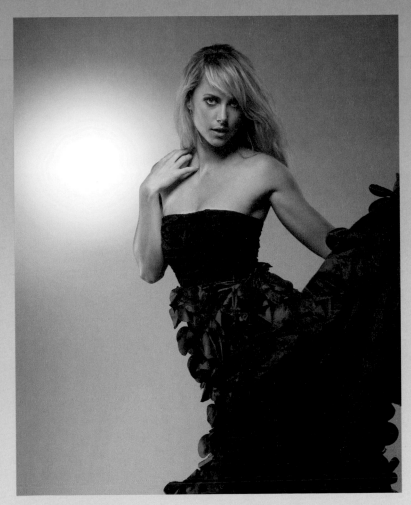

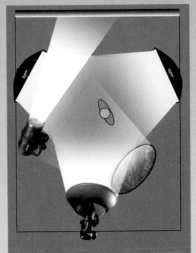

Above right: This image uses a classic closed-loop lighting pattern for the face but requires attention to both fill on the face and into the dark tones of the garment. *Photograph by Tim Meyer.*

Above left: With a beauty dish in a near-Paramount position, the head tilt creates the closed-loop lighting. Because the beauty dish produces a strong beam, the contrast on the face must be managed to avoid too high a lighting ratio. Also, fill is required to open up detail in the dark gown. To meet these two objectives, a collapsible silver reflector was used from the right side and slightly below the model. Accents were added with two 1x6-foot softboxes behind and on either side of the model. Finally, a gridded monoblock was aimed at the background to create the high illumination circle.

of as additive fill. Of the many means available to create fill light, the simplest, least expensive, and usually least intrusive method is to use a reflecting material.

Using a white reflector card is a simple way to add diffuse reflected light. While many materials can be used for this type

SILVER REFLECTORS

When a silver surface is used to add fill light, the light reflected into the subject takes on a slightly diffuse version of the same characteristics of the light illuminating the silver reflector. If the light is coming from a diffuse source, the light will be diffuse. If the source is specular, the fill will be specular. Consider using a sheet of plywood painted white or covered with strips of loose aluminum foil. The end result is an inexpensive, lightweight, and durable reflector panel!

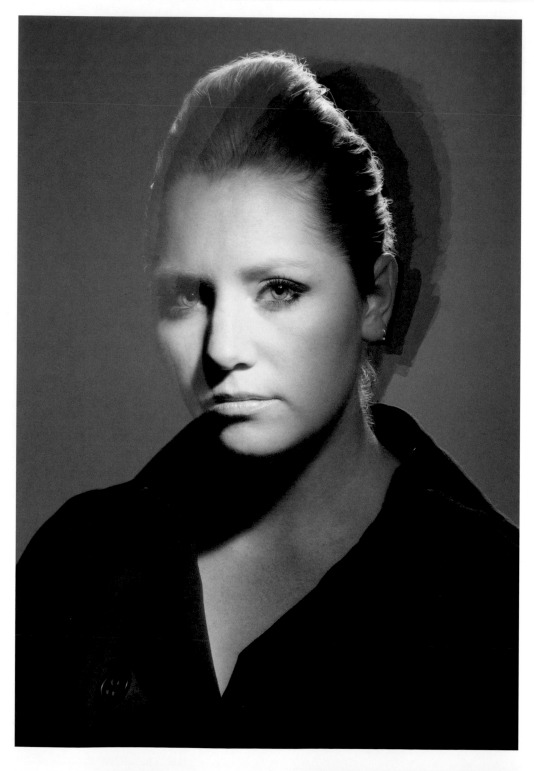

Only one light—a flash positioned behind the subject—was used for this image. The source was positioned so that its beam partially passed through a diffusing panel, which served as a hair light. The remainder of the light came forward and was reflected back onto the subject from silver foil. This reflected light was the main light. After the original flash exposure, a flashlight was used during the remainder of the eight-second exposure. *Photograph by Tim Meyer.*

Shiny surfaces such as this polished nautilus shell tend to be best illuminated with reflected fill light. One Fresnel spotlight was aimed down from the rear right, creating the shadow on the opening of the shell and the specular reflections from the shell. To form the soft highlight reflections on the left side of the shell, a moving white fill card was used to control the light reflecting from the shell's shiny surface. *Photograph by Glenn Rand.*

> **Another lightweight solution available to the photographer is the collapsible reflector.**

of reflector, foam-core boards are an inexpensive lightweight material for this purpose. Another lightweight solution available to the photographer is the collapsible reflector. These reflectors are often constructed with a flexible springy exterior ring structure that stretches a coated fabric material when open. The material on these collapsible reflectors is often metallic on one side and diffuse on the other. Some of these systems have removable and reversible materials that include but are not limited to white, silver, and gold surfaces. In some systems, the outer coverings are reflectors, while the interior is a diffuser.

Many panel constructions have interchangeable fabric. When the diffuser frame is fitted with a white panel, it serves as a large

reflector. The panel's frame can often be fitted with metallic material to create a large specular reflector as well.

For large outdoor scenarios, heavier reflective materials may be more appropriate. Plywood that has been painted white can be a good choice. Regardless of the material, the principle is the same: the white surface of the fill board is used as though it were a mirror to reflect light, whether from a lighting unit or ambient light in the environment.

When adding reflected light, you are simply redirecting the existing light in the scene onto the desired area to fill in shadows. White reflectors are neutral and will not alter the color balance of

This magazine cover image was created using selective reflection. The primary lighting was a Fresnel spotlight directed through a diffuser panel. To give the ceramic piece more roundness, selective reflectors were used. A white fill was used from the front to increase the illumination on the front of the subject. Because of the colors of the ceramic vessel, the brighter illumination on the front brings it forward. To provide a sense of depth in the image, dark-green reflectors were used on either side of the pot. The green is complementary to the reddish color; it helps to reduce the colorfulness of the sides of the subject, allowing them to perceptually retreat. The combination of the higher illumination in the front and less saturated color on the sides gives a more rounded look. Cover photograph by Glenn Rand.

For this image, three objectives had to be met. First, the color of the perfume within the bottle had to be accurate. Second, the shape of the bottle needed to come accross to the viewer. Third, the name of the product, in gold lettering on the front of the bottle, had to stand out. *Photograph by Glenn Rand.*

The set for the above image was designed with a neutral gray satin as the primary background. A snooted light was projected onto the area behind the bottle. A mask was used to restrict the pattern of the light, creating a shape of light that approximates the bottle's form. This was projected onto the satin, and that light reflected through the perfume.

The second consideration was to define the shape of the bottle. This was accomplished with two white reflectors—one on the side and one behind the bottle. The reflectors were relatively thin so that the light reflecting from them would have a minimal effect on the edges of the bottle and its top. To control reflections from the front of the bottle so that no light interfered with the color of the perfume, flags were placed on either side of the bottle. Each fill card was lit separately with a light unit fitted with a 5-degree grid to restrict the spread of the light. It was important that these lights not actually illuminate the bottle.

Last, to ensure that the type would be seen in its own color, a selective fill was used in front of the bottle. The color of the selective reflector in the foreground was goldenrod yellow rather than gold foil. A separate light, fitted with a 5-degree grid, was used to illuminate the selective reflector.

the overall lighting effect. They do not create crossing shadows or other objectionable lighting flaws. While white-surfaced reflectors tend to create fewer lighting issues than other surface types, all laws governing light, such as the Law of the Inverse Square, affect the lighting on the subject. The more textured the surface of the reflector, the more diffuse the light will be as it is projected onto the subject. Also, the more diffuse the reflector surface, the less noticeable the fill light will be.

Not all reflectors are neutral in color. The color of the reflector, whether its surface is specular or diffuse, introduces a color bias into the lighting environment. This is known as *selective reflection*. This approach can be used in portraiture to add a warm tone into the fill. It is also used to create specific color effects in tabletop photography.

A specular reflector, such as a metallic reflector, acts more like a mirror and thus replicates the light striking it as it is reflected onto the subject. A specular reflector under specular light will have a stronger lighting effect on the subject than a diffuse reflector used in the same conditions. While the light reflecting from a specular reflector will have greater intensity on the subject, care must be taken when using metallic, specular reflectors to avoid crossing shadows and other unwanted lighting effects.

REDUCING FILL LIGHT

While positive fill is used to reduce the contrast in a scene for a lower lighting ratio, subtractive fill makes an image contrastier, producing a higher lighting ratio. When naturally occurring fill is removed from the subject, the shadows deepen in comparison to the highlights.

The use of a flag is the most common method of reducing unwanted reflected light on the subject. In photographic parlance, a *flag* is a black piece of material that is used near the subject to ensure that light within the environment does not affect the subject. The black absorptive material does not allow reflections into the area of the subject that it is protecting. The effectiveness of a flag is based on the ambient light that can reach the subject from the side where the flag will be placed.

Normally flags are constructed by stretching a soft-textured black material with light-absorbing characteristics over a rigid

The use of a flag is the most common method of reducing unwanted reflected light . . .

These three illustrations show the effect of positive and negative fill. The left image shows the piece of pottery with the bare bulb main light and ambient light filling the subject. The center image shows the effect of a white, positive fill. The right image shows the effect of using a black flag to create negative or subtractive fill. *Photographs by Glenn Rand.*

A single tool can be used to create fill or absorb unwanted ambient reflections.

frame. Other constructions include rigid solid black boards or stretched black material on collapsible frames. Some flags are constructed with either a secondary hinged complement or a black material flap that can be extended. These hinged or adjustable flags are called *floppies*.

Since a flag is the opposite of a fill, many photographers use a foam core board with one white side and one black side. This way, a single tool can be used to create fill or absorb unwanted ambient reflections.

BLOCKING LIGHT

In some cases, it is necessary to fully block the light striking the subject from a particular direction. In a controlled light environment, the easiest way to accomplish this is to place a blocking device between the light and the subject, thereby casting a shadow.

The simplest idea is to place an opaque form—a *gobo* (short for "go between")—into the light's path. Various tools such as cards, dots, fingers (when they are opaque and relatively close to the subject), and *cutters* (a small flag-like device that is suspended in the path of light) can be used.

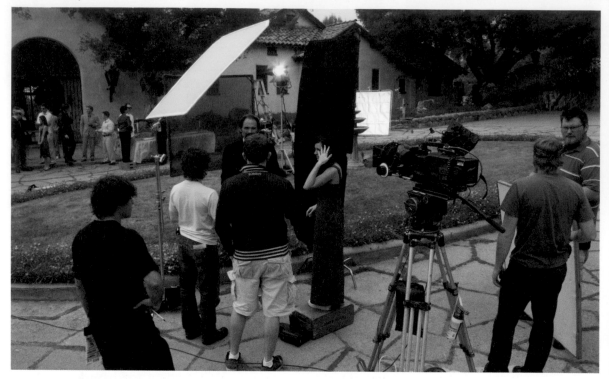

This production image from a motion picture was made using several passive light approaches. First, a diffuser panel was used to control the light as the sun moved across the sky. The use of the diffuser panel ensured that the primary angle of the light would be held constant. A large black flag opposite the diffuser adjusted the contrast by reducing the ambient fill on the primary subjects. A black scrim was placed behind the primary subjects. It was used to reduce the exposure of the background. The large Fresnel light in the back added a controlled fill.

When blocking light, it is important to consider the way that the gobo's surface will impact the subject. A light-toned or colored gobo can create a lightening effect or color cast on the subject. A black gobo will act as a flag and restrict ambient reflections on the subject.

COMPLEX MAIN/FILL

Fill need not always play a supporting role. There are instances when the main light and fill light can be used in combination to introduce two different beam structures in a single image for a complex, precise effect that allows for greater control over the modeling on the subject. This is sometimes called a "light within light" approach.

As mentioned in chapter 2, it is possible to create lighting that crosses traditional boundaries of specular and diffuse. This can

When blocking light, consider the way that the gobo's surface will impact the subject . . .

COMPLEX LIGHTING FOR PORTRAIT VARIETY

These five images show how complex "light within light" concepts can be used to change the look of a subject.

Left: Here, the subject was lit with a 7-foot umbrella with a diffusing sock. This produced diffuse light with a moderate beam, resulting in a characteristic LDE and highlights for minimally diffused light. **Center:** Here, a Profoto Magnum was placed nearly on-axis with the giant reflector. The more specular Magnum was just 1 stop brighter in exposure value than the 7-foot umbrella. This produced slightly more contrast on the model's face with a bit more definition in the shadows. **Right:** The Magnum (same position) was set 3 stops brighter. In the area it lit, there are strong shadows and a crisp LDE. The difference in shadows is strong due to the near-axis light, but the highlights are similar in size with a bit of a difference in brightness. With the Magnum fitted with a 20 degree grid, the light only hits the model's upper torso. The falloff and selective nature of the specular source is most apparent in this image.

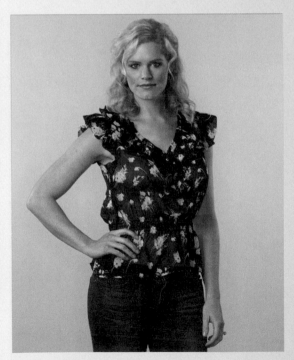 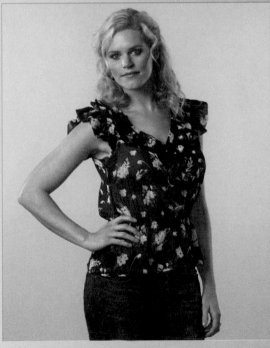

Next, a ring light was used with the socked 7-foot umbrella. For the left image, a ring light was used at –1 stop but did not eliminate the shadows on the model. While some lightened shadow remains on the model, the highlights moved to the center and appear slightly more intense. For the right image, the illumination was set to -3 stops. The ring light added a small amount of fill and left the socked giant umbrella to set the shadows.

be accomplished using a single modified light source or multiple units, each fitted with different modifiers.

The last set of images shows one of the interesting reasons to use a ring light/ring flash as a fill. Particularly in beauty photography, where the plasticity and smoothness of the skin of a model is important, a ring flash provides two major advantages. First, since it is on axis with the camera's lens, it reduces the appearance of small blemishes on the skin. Second, it adds roundness to the face by producing a highlight on the most forward part of the face (the forehead, nose, etc.), allowing those areas to visually advance in the frame.

A "light within light" approach allows using the fill as a main part of the lighting pattern.

While the image effects were enhanced in Photoshop, the understanding of how the light would be shown on and in the object was considered. Since the outer surface was specular polished glass, a broad diffused light, a lit white board, needed to be used from the rear to show the glass globe. With the inner shape being a textured surface, a more specular light was needed to show its various textures. This was accomplished with a snooted light that was confined to just the internal shape below and in front. The bubbles, with their oval shape, reflect both lighting elements. *Photograph by Glenn Rand.*

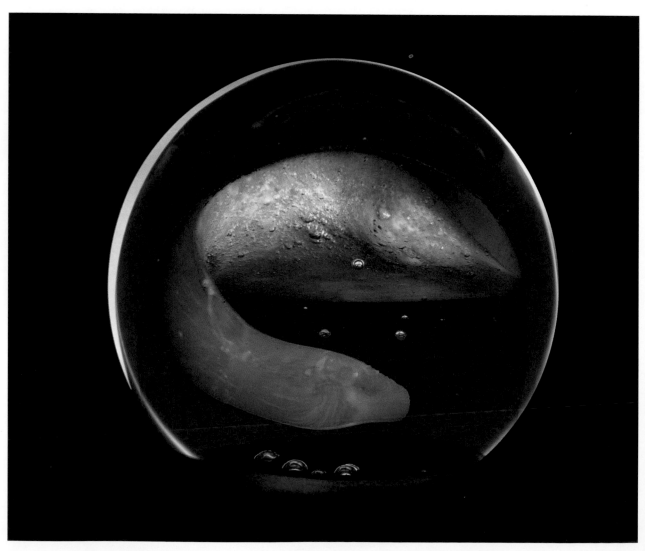

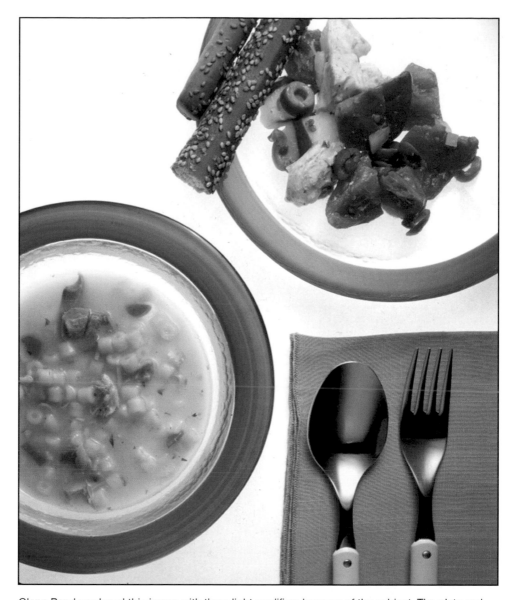

Glenn Rand produced this image with three light modifiers because of the subject. The plate and bowl are clear glass with blue colored rims. This allowed for the soup to have a more translucent and liquid look with the light from a diffuser panel supporting the set and lit from below. The subject lighting was created with light illuminating a diffuser panel above and to the bottom of the image and a large white reflector card above. The upper illuminated diffusion panel and reflector board were angled to meet at the camera, which was directly over the set.

IN REVIEW

1. Fill can be seen as either positive (adding light to the subject) or negative (restricting light from affecting the subject).
2. Adding fill with a reflector is similar to using a mirror to redirect the light onto the subject.
3. Color fill reflectors can add a color bias on the subject receiving the fill. This can add to or reduce the apparent illumination based on the effects of similar and complementary colors on the subject.
4. A flag, a black absorptive material, can be used to reduce the effect of ambient fill. This is considered negative or subtractive fill.
5. Light may need to be blocked to produce the desired lighting pattern.
6. Using a "light within light" approach allows using the fill as a main part of the lighting pattern.

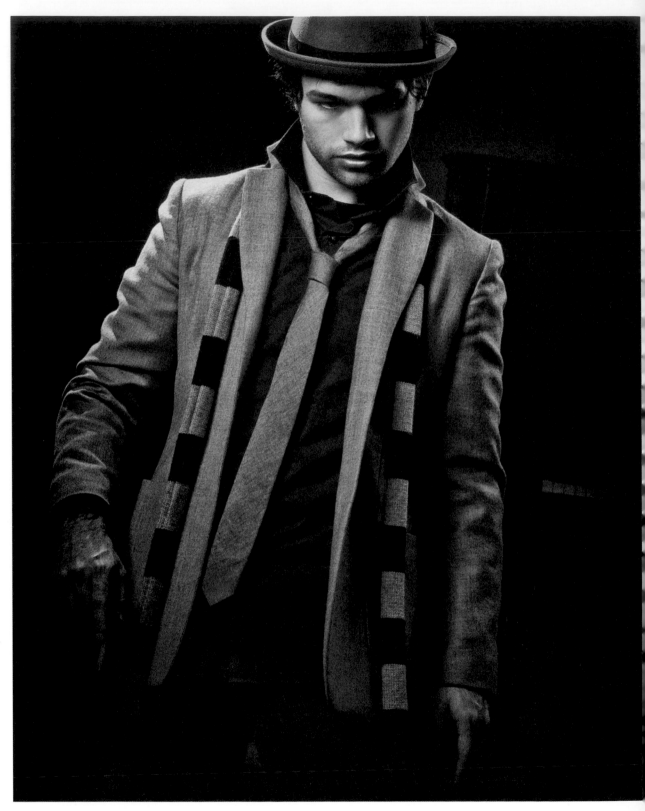

To light this image, a medium softbox from the left side was tilted upward. A speedlight was used to create the rim light accent, and a second medium softbox was aimed up at the subject from the rear right side. *Photograph by Brenden Butler.*

BIOGRAPHIES

GLENN RAND

http://glennrand.com

Glenn Rand's life has always included the pursuit of excellence in various art forms. While he is best known for his photography and photographic teachings, Glenn also teaches, writes about, and instructs others in the fields of illustration and crafts. His photographs are in thirty public museums' collections in the United States, Europe, and Japan, and he has exhibited widely.

Glenn has published and lectured extensively about photography and digital imaging on topics ranging from commercial aesthetics to the technical fine points of lighting. He has authored eleven books including *Film and Digital Techniques for Zone System Photography* and *Lighting for Photography: Techniques for Studio and Location Shoots,* both from Amherst Media. Several of these titles have been translated into Chinese, Korean, and German language versions. He also contributes regularly to various periodicals.

Glenn has taught and administered in public education, community colleges, and universities since 1966. Since 2010, he has been associated with Adrian College in Adrian, Michigan. In conjunction with these academic roles and consulting, he has developed and reorganized several curricula for fine-art photography, commercial photography, digital imaging, and allied curricula.

He received his Bachelor and Master of Arts degrees from Purdue University and earned a doctorate degree from the University of Cincinnati, where he focused on the psychology of educational spaces. He also completed postdoctoral research as a visiting scholar at the University of Michigan.

Glenn's consultant clients have included the Eastman Kodak Company, Ford Motor Company, Photo Marketing Association International, the Ministry of Education of Finland, as well as many other businesses and several colleges.

TIM MEYER

www.meyerphoto.com

Photographer, educator, and author Tim Meyer is passionate about the field of photography. Drawing from over thirty years' experience as a professional photographer, he brings a great deal of expertise and sustained energy to his work. Mixing a rich artistic heritage with today's modern styles, his images enlighten and inspire. Tim possesses the Master of Photography and Photographic Craftsman degrees from Portrait Photographers

of America (PPA) and earned a Master of Art from California State University, Fullerton and a Master of Fine Arts in fine-art photography from Brooks Institute. In addition to numerous one-man exhibitions of his fine-art work, his photography has been internationally recognized for its innovative style and technique. He currently teaches full time and serves as the lead instructor for portraiture at Brooks Institute. His nationally acclaimed portrait and wedding studio, Meyer Photography, is managed by his partner in business and life, Dea Meyer. Tim is honored to be sponsored by H&H Color Lab, Big Folio, and Triple Scoop Music. He also speaks and teaches internationally for the MAC Group Pro Educational Team, representing, among others, Sekonic, Pocket Wizard, Profoto, and Creative Light product lines. Tim's writings on photography and art have been published internationally and his book, *The Portrait: Understanding Portrait Photography* (coauthored with Glenn Rand; Rocky Nook, 2010) is available worldwide.

BRENDEN BUTLER

http://silklightphotography.com
Brenden Butler is a portrait, product, and fine-art photographer. He holds a bachelor's degree from the renowned Brooks Institute in Santa Barbara, California, where his work garnered Best Overall Portfolio honors in a Joan L. Warwick Memorial Grant competition and two Mickey McGuire Scholarship competitions. After graduating from Brooks, Brenden worked closely with fashion photographer Neal Barr to produce a photographic essay on 1920s fashion and accessories. During his apprenticeship, he absorbed Barr's innovative and meticulous approach to styling and lighting. Brenden Butler produces photos and videos for private and commercial clients through his Oregon-based business, Silk Light Photography. He also presents workshops on lighting.

RANDY DUCHAINE

www.randyduchaine.com
Randy Duchaine's clients hire him because they need to tell a story. For more than thirty years, Randy has told people's and organizations' stories through portraits. Sometimes it's the story of how a company improves its customers' lives. It might be the story of a family's pride in their products or services through a business that has been handed down for generations. His visual stories have raised desperately needed funds, motivated people to take action, encouraged people, provided a behind-the-scenes glimpse into how things happen, and even turned preconceived notions inside out.

What sets Randy's images apart is his ability to be inspired by his subjects and to pass that inspiration on to us. Whether the subject is a CEO, puppeteer, or craftsman with a lifelong dedication to pianos, tailored suits, or stone, his portraits provide singular insight into people, making us want to know more about them too. Randy earned an associates degree in liberal arts and a bachelor's and honorary master's degree from Brooks Institute of Photography. He has taught and lectured at Brooks; Fashion Institute of Technology, School of Visual Arts; Public School 51 in Brooklyn; Brooklyn Botanic Gardens; National Arts Club; and other institutions. His images are collected by corporations and are in the permanent collections of the Brooklyn Public Library Archives.

ALLISON FLOWERS

www.allison-flowers.com

Allison Flowers currently lives in Santa Barbara, California where she is pursuing an master of fine arts degree after completing her bachelor of fine arts degree in professional photography with a concentration in portraiture. She also actively pursues her photographic work as a professional portrait photographer while continuing her studies and producing her art. When time allows, some of her favorite companions are friends, wine, cheese, and cupcakes.

JUDY HOST

http://www.judyhost.com

Judy Host is recognized internationally as an accomplished portrait photographer with studios located in California and Georgia. She is known for her ability to tell a story and reflect feelings through her one-of-a-kind portraits. Her ability to paint with light and to tend to the smallest details in a composition has led many to mistake her portraits for paintings.

Judy has won numerous awards for her photography and has been featured in several publications for her outstanding environmental portraiture. In 2004, she was selected by *Rangefinder* as one of Today's Top Children's Photographers. She has earned her Master of Photography and Photographic Craftsman degrees from PPA and was invited to join the organization's program for Sigma pros. She has photographed Jack Nicholson, Pierce Brosnan, Nicole Kidman, Mark Wahlberg, and many other celebrities and has shot for Warner Bros. studios. Judy teaches workshop series titled "The Art of Available Light" and "Behind the Image: The Creative Process" throughout the year.

THOMAS JAMES

www.tommyjphoto.com

In autumn of 2002, Thomas James fell into the craft of photography. From then until the early part of 2010, he was self-taught and learned as much as he could about the image-making process through books, experience, etc. Later realizing he needed some formal education on the subject to compete in the market, he decided to enroll at Brooks Institute. Since then, he has refined his focus and style and has directed his focus toward editorial portraiture. Using a delicate balance of interactions with the model and refined lighting techniques, he is able to create an image that provides a glimpse into the personality and life of the subject.

NICK KOROMPILAS

www.koromp.com

Nick Korompilas was born and raised in Sacramento, California. Upon high-school graduation he traveled south to Santa Barbara, pursuing an education and career in professional photography. He specializes in several styles—predominately editorial and fine-art photography—but he is taking his work one step at a time and finding new techniques through the use of different photographic processes. As a young photographer, he has plenty of room for growth and chooses to allow patience and hard work to lead his way as opposed to a label. So far, his work has allowed him many wonderful opportunities and a reason to travel and explore the world.

INDEX

OTHER BOOKS FROM
Amherst Media®

The Portrait Photographer's Guide to Posing, 2nd Ed.

Bill Hurter calls upon industry pros who show you the posing techniques that have taken them to the top. $34.95 list, 8.5x11, 128p, 250 color images, 5 diagrams, index, order no. 1949.

The Art of Off-Camera Flash Photography

Lou Jacobs Jr. provides a look at the lighting strategies of ten portrait and commercial lighting pros. *$34.95 list, 8.5x11, 128p, 180 color images, 30 diagrams, index, order no. 2008.*

Advanced Underwater Photography

Larry Gates shows you how to take your underwater photography to the next level and care for your equipment. *$34.95 list, 8.5x11, 128p, 225 color images, index, order no. 1951.*

Boutique Baby Photography

Mimika Cooney shows you how to create the ultimate portrait experience—from start to finish—for your higher-end baby and maternity portrait clients. *$34.95 list, 7.5x10, 160p, 200 color images, index, order no. 1952.*

Behind the Shutter

Salvatore Cincotta shares the business and marketing information you need to build a thriving wedding photography business. *$34.95 list, 7.5x10, 160p, 230 color images, index, order no. 1953.*

Studio Lighting Unplugged

Rod and Robin Deutschmann show you how to use versatile, portable small flash to set up a studio and create high-quality studio lighting effects in *any* location. $34.95 list, 7.5x10, 160p, 300 color images, index, order no. 1954.

Master's Guide to Off-Camera Flash

Barry Staver presents basic principles of good lighting and shows you how to apply them with flash, both on and off the camera. $34.95 list, 7.5x10, 160p, 190 color images, index, order no. 1950.

Lighting for Architectural Photography

John Siskin teaches you how to work with strobe and ambient light to capture rich, textural images your clients will love. *$34.95 list, 7.5x10, 160p, 180 color images, index, order no. 1955.*

Hollywood Lighting

Lou Szoke teaches you how to use hot lights to create timeless Hollywood-style portraits that rival the masterworks of the 1930s and '40s. *$34.95 list, 7.5x10, 160p, 148 color images, 130 diagrams, index, order no. 1956.*

500 Poses for Photographing High School Seniors

Michelle Perkins presents head-and-shoulders, three-quarter, and full-length poses tailored to seniors' eclectic tastes. *$34.95 list, 8.5x11, 128p, 500 color images, order no. 1957.*

LED Lighting: PROFESSIONAL TECHNIQUES FOR DIGITAL PHOTOGRAPHERS

Kirk Tuck's comprehensive look at LED lighting reveals the ins-and-outs of the technology and shows how to put it to great use. *$34.95 list, 7.5x10, 160p, 380 color images, order no. 1958.*

Nikon® Speedlight® Handbook

Stephanie Zettl gets down and dirty with this dynamic lighting system, showing you how to maximize your results in the studio or on location. *$34.95 list, 7.5x10, 160p, 300 color images, order no. 1959.*

Step-by-Step Posing for Portrait Photography

Jeff Smith provides easy-to-digest, heavily illustrated posing lessons designed to speed learning and maximize success. *$34.95 list, 7.5x10, 160p, 300 color images, order no. 1960.*

Lighting Essentials: LIGHTING FOR TEXTURE, CONTRAST, AND DIMENSION

Don Giannatti explores lighting to define shape, conceal or emphasize texture, and enhance the feeling of a third dimension. *$34.95 list, 7.5x10, 160p, 220 color images, order no. 1961.*

50 Lighting Setups for Portrait Photographers, VOLUME 2

Steven Begleiter provides recipes for portrait success. Concise text, diagrams, and screen shots track the complete creative process. *$34.95 list, 7.5x10, 160p, 250 color images, order no. 1962.*

Legal Handbook for Photographers, THIRD EDITION

Acclaimed intellectual-property attorney Bert Krages shows you how to protect your rights when creating and selling your work. *$29.95 list, 7.5x10, 160p, 110 color images, order no. 1965.*

DOUG BOX'S
Available Light Photography

Popular photo-educator Doug Box shows you how to capture (and refine) the simple beauty of available light—indoors and out. *$29.95 list, 7.5x10, 160p, 240 color images, order no. 1964.*

THE BEST OF **Senior Portrait Photography**, SECOND EDITION

Rangefinder editor Bill Hurter takes you behind the scenes with top pros, revealing the techniques that make their images shine. *$29.95 list, 7.5x10, 160p, 200 color images, order no. 1966.*

Flash Techniques for Location Portraiture

Alyn Stafford takes flash on the road, showing you how to achieve big results with these small systems. *$29.95 list, 7.5x10, 160p, 220 color images, order no. 1963.*

Christopher Grey's Posing, Composition, and Cropping

Make optimal design choices to create photos that flatter your subjects and meet clients' needs. *$29.95 list, 7.5x10, 160p, 330 color images, index, order no. 1969.*

500 Poses for Photographing Children

Michelle Perkins presents head-and-shoulders, three-quarter, and full-length poses to help you capture the magic of childhood. *$34.95 list, 8.5x11, 128p, 500 color images, order no. 1967.*

Painting with Light

Eric Curry shows you how to identify optimal scenes and subjects and choose the best light-painting sources for the shape and texture of the surface you're lighting. *$29.95 list, 7.5x10, 160p, 275 color images, index, order no. 1968.*

75 Portraits by Hernan Rodriquez

Conceptualize and create stunning shots of men, women, and kids with the high-caliber techniques in this book. *$29.95 list, 7.5x10, 160p, 150 color images, 75 diagrams, index, order no. 1970.*

DON GIANNATTI'S **Guide to Professional Photography**

Perfect your portfolio and get work in the fashion, food, beauty, or editorial markets. Contains insights and images from top pros. *$29.95 list, 7.5x10, 160p, 220 color images, order no. 1971.*

Master Posing Guide for Portrait Photographers, 2nd Ed.

JD Wacker's must-have posing book has been fully updated. You'll learn fail-safe techniques for posing men, women, kids, and groups. *$29.95 list, 7.5x10, 160p, 220 color images, order no. 1972.*

Available Light Glamour Photography

Joe Farace teaches you how to harness natural, man-made, and mixed lighting to create sensuous images anywhere. *$29.95 list, 7.5x10, 160p, 200 color images, order no. 1973.*

Flash Photography

Barry Staver shows you how to approach lighting with flash in a clear, systematic way that produces outstanding results Includes studio and location techniques. *$29.95 list, 7.5x10, 160p, 340 color images, order no. 1974.*

The Flash Stick

Rod and Robin Deutschmann teach you how to use a simple, inexpensive device called a flash stick to position a flash wherever it's needed—without an assistant. *$24.95 list, 7.5x10, 96p, 210 color images, order no. 1975.*

Backdrops and Backgrounds
A PORTRAIT PHOTOGRAPHER'S GUIDE

Ryan Klos' book shows you how to select, light, and modify man-made and natural backdrops to create standout portraits. *$29.95 list, 7.5x10, 160p, 220 color images, order no. 1976.*

Photographing Dogs

Lara Blair presents strategies for building a thriving dog portraiture studio. You'll learn to attract clients and work with canines in the studio and on location. *$29.95 list, 7.5x10, 160p, 276 color images, order no. 1977.*

Lighting for Product Photography

Allison Earnest shows you how to select and modify light sources to capture the color, shape, and texture of an array of products. *$29.95 list, 7.5x10, 160p, 195 color images, order no. 1978.*

Posing for Portrait and Glamour Photography

Joe Farace provides essential strategies for idealizing portrait subjects and creating flattering, evocative images that sell. *$29.95 list, 7.5x10, 160p, 260 color images, order no. 1979.*

500 Poses for Photographing Groups

Michelle Perkins provides an impressive collection of images that will inspire you to design polished, professional portraits. *$34.95 list, 8.5x11, 128p, 500 color images, order no. 1980.*

Just Available Light
TECHNIQUES FOR DIGITAL PHOTOGRAPHERS

Rod and Robin Deutschmann show you how to capture high-end images of portrait and still-life subjects. *$19.95 list, 7.5x10, 96p, 220 color images, order no. 1981.*

Direction & Quality of Light

Neil van Niekerk shows you how consciously controlling the direction and quality of light in your portraits can take your work to a whole new level. *$29.95 list, 7.5x10, 160p, 194 color images, order no. 1982.*

THE ART AND BUSINESS OF HIGH SCHOOL
Senior Portrait Photography,
SECOND EDITION

Ellie Vayo provides critical marketing and business tips for all senior portrait photographers. *$29.95 list, 7.5x10, 160p, 340 color images, order no. 1983.*

Figure Photography

Billy Pegram provides a comprehensive guide to designing desirable commercial and fine-art figure images. *$29.95 list, 7.5x10, 160p, 300 color images, order no. 1984.*

Step-by-Step Lighting for Studio Portrait Photography

Jeff Smith teaches you how to develop a comprehensive lighting strategy that truly sculpts the subject for breathtaking results. *$29.95 list, 7.5x10, 160p, 275 color images, order no. 1985.*

Creating Stylish & Sexy Photography
A GUIDE TO GLAMOUR PORTRAITURE

Chris Nelson provides the key information you need to bring out the sensual side in every client. *$19.95 list, 7.5x10, 96p, 200 color images, order no. 1986.*

Modern Bridal Photography Techniques

Get a behind-the-scenes look at some of Brett Florens' most prized images—from conceptualization to creation. *$29.95 list, 7.5x10, 160p, 200 color images, 25 diagrams, order no. 1987.*

Create Erotic Photography

Richard Young shows you how to create expert, evocative, and sexy shots with minimal gear. *$27.95 list, 7.5x10, 160p, 200 color images, 25 diagrams, order no. 1988.*

Photographing the Child

Jennifer George shows you how to use natural light, myriad locations, and a fun, kid-friendly approach to bring out every child's best in front of the lens. *$27.95 list, 7.5x10, 160p, 225 color images, order no. 1989.*

Location Lighting Handbook for Portrait Photographers

Stephanie and Peter Zettl provide simple techniques for creating elegant, evocative, and expressive lighting for subjects in any location. *$27.95 list, 7.5x10, 160p, 200 color images, order no. 1990.*

500 Poses for Photographing Infants and Toddlers

Michelle Perkins shares a host of top images from the industry's best to help you conceptualize and deliver the perfect kids' poses. *$34.95 list, 8.5x11, 128p, 500 color images, order no. 1991.*

Commercial Photographer's Master Lighting Guide, 2nd Ed.

Robert Morrissey details the advanced lighting techniques needed to create saleable commercial images of any subject or product. *$27.95 list, 7.5x10,*

The Best of Wedding Photography, 3rd Ed.

Bill Hurter shows you how top photographers transform special moments into lasting romantic treasures. *$39.95 list, 8.5x11, 128p, 200 color photos, order no. 1837.*

Photographing Children with Special Needs

Karen Dórame explains the symptoms of spina bifida, autism, cerebral palsy, and more and offers tips for conducting a safe shoot. *$29.95 list, 8.5x11, 128p, 100 color photos, order no. 1749.*

Simple Lighting Techniques
FOR PORTRAIT PHOTOGRAPHERS

Bill Hurter shows you how to streamline your lighting for more efficient shoots and more natural-looking portraits. *$34.95 list, 8.5x11, 128p, 175 color images, index, order no. 1864.*